Treasury of
Authentic Art Nouveau Alphabets, Decorative Initials, Monograms, Frames & Ornaments

EDITED BY
LUDWIG PETZENDORFER

DOVER PUBLICATIONS, INC.
NEW YORK

Published in Canada by General Publishing Company, Ltd., 30 Lesmill Road, Don Mills, Toronto, Ontario.
Published in the United Kingdom by Constable and Company, Ltd.

Treasury of Authentic Art Nouveau Alphabets, Decorative Initials, Monograms, Frames and Ornaments, first published by Dover Publications, Inc., in 1984, is a slightly altered republication of *Schriftenatlas Neue Folge: Eine Sammlung von Alphabeten Initialen und Monogrammen zusammengestellt von Hofrat L. Petzendorfer* ("Type portfolio, new series: A collection of alphabets, initials and monograms compiled by Privy Councillor L. Petzendorfer"), originally published by Julius Hoffmann, Stuttgart, ca. 1903. The Publisher's Note (which details the minor alterations in this reprint edition) and the Glossary have been prepared specially for this edition by Joseph M. Cahn.

DOVER *Pictorial Archive* SERIES

Manufactured in the United States of America
Dover Publications, Inc., 31 East 2nd Street, Mineola, N.Y. 11501

Library of Congress Cataloging in Publication Data
Main entry under title:

Treasury of authentic art nouveau alphabets, decorative
 initials, monograms, frames and ornaments.

Captions in German.
 1. Decoration and ornament—Art nouveau. 2. Alphabets.
3. Initials. 4. Monograms. 5. Borders, Ornamental
(Decorative arts). I. Petzendorfer, Ludwig, b. 1851.
NK3625.A73T73 1984 745.6'197'0904 83-20646
ISBN 0-486-24653-1

PUBLISHER'S NOTE

DURING the twenty-year period around the turn of the century, a new approach to design swept the studios, workshops and academies of Europe and America. The Art Nouveau movement touched every discipline of the applied arts, resulting in a dreamy, sensuous style that continues to fascinate artists and craftspeople nearly a hundred years after its first flowering. Its expression in typographic design was rich and fluent, infinitely varied in its particulars, but cohesive in its unifying spirit of organic composition. This opus, essentially a facsimile of what is arguably the greatest album of Art Nouveau typography produced during the heyday of the style, is a remarkably comprehensive survey of the nonpictorial graphic design of the age.

The *Schriftenatlas* ("Type Portfolio") from which this book is reproduced was issued by the Stuttgart house of Julius Hoffmann, a specialist in publications for artists and designers. (Hoffmann also published the influential stylebook *Dekorative Vorbilder*, selections from which are available in *300 Art Nouveau Designs and Motifs*, edited by Carol Belanger Grafton [Dover, 1983, 24354-0].) The *Neue Folge* ("New Series") that is the basis of the present volume appears to have been brought out around 1903.

The original publisher's foreword (not reprinted here) noted the influence of the "modern art movement" (i.e., Art Nouveau) on the design of type and lettering. The stated aim of the *Schriftenatlas* was "to offer a collection of the best new typefaces and thus provide an overview of the growing movement in the area of typography." Under the editorial direction of L. Petzendorfer, who had compiled an earlier issue of the *Schriftenatlas* ("still unsurpassed," declared the foreword), specimens of type, ornaments, borders, initials, monograms and so on from no fewer than 38 of the leading type foundries of Germany, Austria, France, England and the United States were brought together in a lavishly printed album. The original volume contained no information about the compiler except his title *Hofrat*, indicating that he held a minor municipal office. The Library of Congress has ascertained that his first name was Ludwig and that he was born in 1851.

Type specimen books published for the trade served not only as catalogs of the foundry's or printer's stock, but also as samples of the quality of printing possible with the type offered. Deluxe presentation of specimen books was usual in this period, and the *Schriftenatlas*, unconventional though it was in other respects, was no exception to this rule. By gathering together the production of many foundries, Hoffmann performed a valuable advertising service for the type houses of several countries, encouraging international commerce and extending market outreach for the client foundries. At the same time, Hoffmann (a printing establishment as well as a publisher) aimed to secure its own business interests, and to promote the talents of artists associated with it. By showing designers the graphic possibilities of newly developed as well as established lines of foundry type and ornament, the house of Hoffmann hoped to encourage "artistic" composition and printing. To this end, the *Schriftenatlas* included a number of specially commissioned typographic and calligraphic designs from leaders in the field, contributing to the spread of the Art Nouveau gospel.

As was customary in specimen books of the era, the *Schriftenatlas* was printed in several colors, usually two to a page, for an added dimension of visual interest. The Dover *Treasury* is entirely in black and white. In the section of alphabets, three settings (Tintoretto and Iris, Plate 46, and Grotesk-Kursiv, Plate 57) which were designed to be printed in two colors are reproduced here with the lighter of the two original colors filtered out, but the effects of shadowing, outlining and partial filling in are retained. In the original edition, the chromatic

values were given special play on the pages devoted to decorative initials. Such characters were usually cast in two pieces that would be inked separately and printed in register to achieve the desired effect. In most cases, these types were cut so that the areas of different colors were discrete. Consequently, none of the form or detail is lost in the conversion to black and white. In a few cases where the areas of color were connected within a given piece, a tint of gray has been introduced in the reproduction process to hold the contrasting values. In the exemplary layouts on Plates 95–101 and 121–141, the type and borders that originally appeared in contrasting hues within each design are uniformly black in the Dover edition. Apart from the matter of color, the *Treasury* departs from the original *Schriftenatlas* only in the slightly smaller page size, the printing on both sides of the page and the binding (paper as opposed to cloth-covered boards).

Each specimen of type is identified in a legend set in a small, utilitarian sans-serif face above the sample, giving the trade name of the typeface set off in quotation marks (variously styled in the German, French or English manner) and the name and location of the foundry that produced it. Other plates are labeled with the name of the designer and a brief tag ("designed by" or the like). The identifications are reproduced here just as they appeared in the original *Schriftenatlas*. A glossary of German and French terms used in the legends, the Table of Contents and the Index follows this Note.

The naming of typefaces, then as now, is a confusing business. There has never been a universally accepted system of typographic nomenclature. Foundries designated their products on commercial rather than scholarly or esthetic bases. The traditional practice of naming typefaces for their designers is evident here, but without a consistent pattern. Some of the names are generic; others are descriptive; still others make reference to historical precedence, especially in instances of revivals, or even geographical provenience. Many names suggest a mood, period or region that the faces might evoke, and quite a few names are purely fanciful.

Almost half of the *Treasury* is devoted to specimens of type meant primarily for display. In all there are 137 complete alphabets (upper and lower case) and 23 settings of capital letters only. These are not complete fonts in the strict sense: punctuation, accents and other sorts are absent, but most of the specimens have full showings of numerals. Some of the alphabets have alternate characters, especially swashes. Almost every plate features a few words set in the type shown, usually personal or place names with international currency. Ligatures occur in some of the fonts. Some, such as ch, ck and tz, and combinations of long s (ſ) followed by s, t, or z, were conventionally joined in German type fonts just as fi and fl are usually cast as ligatures in English and American fonts. Others, such as ae and oe, were commonly used in several languages in words of classical origin or as variant forms for the umlauted a or o. Still others, such as the la, th and tt ties shown in the specimen of Künstler-Grotesk (Plate 47), were designed as special characters to solve copy-fitting problems or to achieve special effects.

Although there is no systematic classification of type styles in the arrangement of specimens in the *Treasury* (perhaps because so many of the faces defy such classification), certain generic groupings are apparent. Most of the 20 or so strictly Gothic faces are shown at the beginning of the book, in keeping with their importance in German printing. About a dozen more or less standard Roman and Italic faces are scattered among the nearly 90 examples of ornamented or grotesque display types. There are also more than a dozen settings of script types.

Thirty of the faces included in this book also appear in *Art Nouveau Display Alphabets: 100 Complete Fonts*, selected and arranged by Dan

X. Solo from the Solotype Typographers Catalog (Dover, 1976, 23386-3), and can be set to specifications by that house (298 Crestmont Drive, Oakland, California 94619). The typefaces are Arnold Böcklin (Bocklin), Artistik, Baldur, Bambus-Grotesk (Bambus), Constantia, Desdemona (Quaint Open), Edda, Edelgotisch (Carmen), Elefanta, Franconia, Harlech, Harquil, Harrington, Kalligraphia (Kaligraphia), Laclede, Métropolitaines (Metropolitan), Mira, Multiform, Negrita, Neptun (Neptune), Oceana, Pretorian (Pretoria), Quaint Roman, Siegfried, Skjald, Thalia, Tip Top, Virile Open, and two others identified in the *Treasury* by the designer rather than by trade name: M. J. Gradl's drawn letters at the top of Plate 23A (Kobe Open) and Peter Schnorr's drawn letters in the middle of Plate 12 (Odessa). (Wherever names appear within parentheses in the listing above, they are Solo's names that differ from Petzendorfer's.)

Following the specimens of display type are 33 complete sets of decorative initials in a rich profusion of styles. There are such venerable designs as Elzevier, named for the great sixteenth-century Dutch printing family and applied more to the manner of ornamentation than to the letter forms themselves. Others are pure Art Nouveau or Secession-style in their typographic design and in their decoration. Still others are hybrids such as the Romana Initialen on Plate 71, which combine a classic Roman face with fluid, plant-inspired forms in outline writhing about and within the letters. Ethel Larcombe adorned her initials (Plate 72) with pictures of women whose flowing hair fills every space. Another favorite Art Nouveau motif, the rose, embellishes the Grange Series of initials on Plates 80 and 81.

Considerable space is allotted to monograms: 17 pages contain a total of 1,900 inventive combinations of two or three letters each. The designs range from plain to fancy; some are enclosed in tiny frames, others are free-standing. This section is supplemented by displays of 51 novel hand-lettered constructions of Christian names, with characters interlaced in monogram fashion.

The balance of the *Treasury* is devoted to what the original publisher's foreword described as "examples of artistically carried out applications of type [which] produce an extraordinarily interesting enrichment of the work, extremely worthwhile for type designers [and] suitable to advance understanding of ornamental arrangement and application of letters and typefaces." These plates (95–101 and 121–141) present a remarkable variety of typographic and calligraphic designs for all kinds of commercial uses: title pages, labels for packaged goods, shop signs, stationery, logos, showcard announcements and layouts for advertisements and programs. This material features many borders, frames, cartouches and ornaments of great charm and obvious utility.

The Art Nouveau style in typographic design developed concurrently in several countries, with much borrowing across national lines. Germany's place in this evolutionary process was peculiar, in part because of the nation's unique typographical heritage. Germany was, of course, the birthplace of printing with movable type, and has been a leading center of the printing arts down through the centuries. The Germans' high level of technical achievement in this field was widely recognized during the nineteenth century, and many of the important advances in printing machinery and technique were made by them. Stylistically, Germany followed a largely separate path from the rest of Europe right up to the period of the *Schriftenatlas*.

The earliest printing types were patterned after the dense, angular characters of the prevalent manuscript hand in Germany. These types, usually called Gothic (although this term is also applied to sans-serif faces of even weight typical of the nineteenth and especially the twentieth centuries) or blackletter, were used all over Europe at the dawn of printing. In Renaissance Italy, new types based on the humanistic hands of the time and place and on classical models supplanted the heavy northern Gothics and evolved into the familiar Roman and Italic styles that have predominated in most printing ever since. In England (and later in America), Gothic types continued to be used in legal and ecclesiastical printing for several centuries, but came to be regarded as illegible and gradually fell into disuse, except in special applications. In Germany and Austria, Roman typefaces made limited inroads, but Gothics of various kinds remained the everyday types for nearly five centuries.

The use of the distinctive typefaces tended to isolate the German lands. With increasing international exchanges of goods, services and ideas, some in Germany felt the need to bring their letters into line with European norms. Others resisted the abandonment of the traditional German typefaces, which through long use had come to be regarded as a graphic embodiment of national identity. While conflicts between nationalist and internationalist sentiments raged, several deliberate attempts were made to make the native typefaces more like the Romans used elsewhere on the Continent. One early modification was the *Centralschrift* designed in the 1830s, which combined the rounded contours and hairline serifs of *Antiqua* (the German term for Roman types, an allusion to their origin in classical models) with the characteristic letter forms of *Fraktur* (the dominant German style, so called for the "broken" appearance of the curves of the letters, particularly in the upper case). More than half a century later, when the Rudhard'schen Type Foundry of Offenbach-am-Main commissioned Otto Eckmann to devise a suitably "modern" typeface, the artist incorporated many features of the *Centralschrift* in his new design (see Plates 2 and 74), which became one of the most popular and representative faces of the Art Nouveau era in Germany.

Reforms notwithstanding, the Germans clung to their Gothic types well into the twentieth century, developing a whole range of different styles for book and newspaper composition, advertising and other special uses. Historically, the two most important German type families are the *Schwabacher*, represented here in a modernized, bold version on Plate 6 and also in an ornamented initial version on Plate 78, and the *Fraktur*. In broad terms, Fraktur types evolved from Schwabacher types, and became dominant from the sixteenth century onward. The capitals, usually highly embellished, are derived from uncials, early medieval manuscript letters that are an intermediate stage in the development of small letters from capitals. Most of the lower case characters have pointed serifs which preserve the strokes of the pen in the ancestral manuscript forms, giving the alphabet its distinctive spiky texture.

To eyes accustomed to Roman types, certain Fraktur letter forms are very strange. The capitals have almost no straight lines. Smooth curves are interrupted by abrupt angles. In the font displayed on Plate 1 (Mainzer Fraktur), the capital A is almost identical to the U, differing only in the direction of the curve of the left "arm." The first Fraktur majuscule has neither the closed top nor the crossbar of the Roman A. The two letters E and F, fraternal twins in Roman, are utterly different in shape in Fraktur. Both show clear traces of their uncial origin. Both H and K look more like minuscules than majuscules, again betraying uncial ancestry. The I (in this setting undifferentiated from the J, which does appear as a separate character in most of the specimens) is far more sinuous in shape than its rigid Roman counterpart. The Fraktur S is like no other. Its origins are obscure, and its shape can deceive the uninitiated reader into mistaking it for a G. The Fraktur V, W and Y, like the M, have neither the diagonal strokes nor the symmetry they have in Roman types. The X is always barred; the Z has the fluidity of handwriting.

In the lower case, several characters have distinctive shapes, notably k, s, w, x, y and z. To the untrained eye, the k appears to be an overly tall and ornamented t, as it lacks the diagonal "legs" that mark it in Roman. The s has two forms, the long one (ſ) used in initial and medial positions and the short one, restricted to the final position. The long s was used in English, among other languages, as late as the eighteenth century, but became obsolete except in German, where it persists in contemporary fonts in the ligature ß (double s). The last four minuscules each have characteristic forms in Fraktur. The left counter of the w is open; the x has a balled flourish that descends below the base line; the y combines features of the w (the open counter) and the h (the scimitar-like tail); and the z has a cursive shape. The construction of ascenders and descenders also contributes to the "look" of the typeface: b, h and k are split at the top; the upper part of d is canted to the left; f, p, q and the long s come to a dagger-like point. Many of these formal quirks recur in the new designs of the Art Nouveau period even as the overall appearance of the faces diverges from the Gothic.

The revitalization of German typography through the reinterpreta-

tion of traditional letter forms was but one aspect of the radical reorientation of the type designer's art at the turn of the century. Stylistic innovation in type design transcended national boundaries, as the range of type styles in this international anthology clearly demonstrates. In many important respects, the design of new typefaces in the Art Nouveau decades followed the new directions taken in all of the applied arts. The new styles of lettering echoed the serpentine rhythms that make *fin-de-siècle* art objects of all kinds seem to writhe with strange life. An obvious example of this is Arnold Böcklin (Plate 49), a face that has taken on a latter-day association with the "psychedelic" art movement of the 1960s, when it enjoyed a major revival. These letters have foliated details and flourishes growing out of the forms like vines on a trellis.

The radically new letter forms devised in this period reflect the interdependence of the various arts and crafts and the versatility of their creators, who were often active in several disciplines. The technical demands of different media influenced the changing shapes of letters intended to be worked in wood, metal, fabric, masonry or precious stones, as well as on paper. A lettering design for, say, a book cover, would be adapted without much alteration for jewelry or architectural decoration, or vice versa. The interchangeability of design elements gives the graphics as well as the three-dimensional artifacts of the age an unmistakable look, true to the spirit of harmonious design in all things.

The elaboration of the Art Nouveau typographic idiom is indivisible from the growth of poster art in the same period. In posters produced by lithography, lettering was executed by hand directly on the stone. The mechanical strictures of type and form were absent in this reproduction technique. Artists could letter freely, imitating the rhythms of handwriting, sign-painting or other informal scripts—effects difficult or impossible to achieve with the usual foundry type. The design of such letters matched the modish style of illustration and helped fuse the graphic elements into a unitary whole. As poster art popularized this freestyle lettering, type founders were encouraged to cast metal type that simulated it. Examples are Ferdinand (Plate 28), Komet (Plate 48), Artistik (Plate 49), Regina-Cursiv and Hansa-Cursiv (Plate 56) and Harquil Series (Plate 61).

The international revival of calligraphy around the turn of the century was an important factor in the development of new typefaces. Largely inspired by the Englishman William Morris's original type designs after medieval models, typographers all over Europe and America began to incorporate features of historic manuscript hands into new type designs. The renewed interest in calligraphic technique left clear traces in such designs as Rundgotisch (Plate 3), Neudeutsch (Plate 4) and Behrens-Schrift (Plate 9), all of which have patterns of thick and thin strokes that show the frank influence of the broad pen. It is interesting to note that although it was a repudiation of technology and its deadening effect on craftsmanship that led graphic artists back to the ancient art of hand-lettering, the technical innovation of photoengraving helped make it practical for calligraphy to regain a place in books and other printed matter.

The design vocabulary of Art Nouveau typography was wonderfully varied. Its practitioners drew upon the long Western traditions in type and lettering for novelty of form and effect, borrowing as readily from styles remote from them in time as from fashions that immediately preceded them. The lingering taste of Victorian gingerbread is perceptible in such designs as Edison (Plate 18), Chaucer and Culdee (Plate

24), Eureka (Plate 25) and of course Victoria (Plate 39). The designers went further afield for new ideas to achieve special effects. The Japanese influence on the entire movement is well known. Georges Auriol's famous design, here called Française Légère (Plate 32), mimicked the brush writing of that tradition. Other typefaces in this collection with a Far Eastern flavor are Neue Pittoresk (Plate 45) and Komet (Plate 48). Offenbacher Reform (Plate 1), Reklame (Plate 45) and Patent Reklame (Plate 64) have thick horizontal elements reminiscent of square Hebrew characters. Experimentation with variations of weight, color (in the typographic sense), distortion, irregular lining, exaggeration of details and unusual finish yielded an astonishing diversity of form and effect.

Twenty-five individual designers and artists are named in the legends, most of them in the pages devoted to "applications of type." Several of them were outstanding figures in fine and applied arts at the turn of the century. Georges Auriol (1863–1938) is especially well remembered for the delicate Japanese-influenced typeface mentioned above. Compositions by him in a similar style of lettering appear on Plates 100 and 101. His most important contribution to commercial graphics was a three-volume collection of monograms, trademarks, seals and bookplates. Along with Alphonse Maria Mucha and Maurice Pillard Verneuil, Auriol executed a stylebook that has been published in facsimile by Dover (*Art Nouveau Designs in Color*, 1974, 22885-1).

Peter Behrens (1868–1940), a native of Hamburg, was a leader of the Munich Secession. He was active as an architect and painter as well as a graphic artist. Johann Vincenz Cissarz (1873–1942), born in Danzig, was associated with the Darmstadt artist colony at the time the *Schriftenatlas* was published. Otto Eckmann (1865–1902), a painter, graphic artist and designer, was one of the most distinguished of the *Jugendstil* group. George Montague Ellwood (b. 1875) was an English architect and interior designer. M. J. Gradl was the general editor of a portfolio issued by Julius Hoffmann around 1900 that has been republished by Dover as *Authentic Art Nouveau Stained Glass Designs in Full Color* (1983, 24362-1). Eugène Grasset (1841–1917), a native of Lausanne, Switzerland, is renowned for his poster designs. Georges Lemmen, a German, worked in Belgium with the influential Henry Van de Velde. William Morris (1834–1896), a founder of the Arts and Crafts movement, excelled in many fields. As a typographer, he is famous as the head of the Kelmscott Press. (Selected leaves from his edition of Chaucer are collected in *Ornamentation and Illustration from the Kelmscott Chaucer*, 1973, 22970-X.) Bruce Rogers (1870–1957) was America's pioneering book designer. (His *Paragraphs on Printing* is available in a Dover edition [1979, 23817-2].) A. A. Turbayne, who was associated with the Carlson Studio, was the author of *Monograms and Ciphers* (Dover, 1968, 22182-2).

Beyond the *Treasury's* obvious utility as a "swipe-file," today's users will find it invaluable for identifying typefaces that are rarely offered by contemporary type houses. Students of design will appreciate the broad survey of Art Nouveau typography contained in its pages, totally authentic not only in its elements, but also in the ensemble, which reflects the taste and judgment of influential artists when the style was at its zenith. Typophiles will enjoy browsing through it, and perhaps some will follow the lead of Ed Benguiat, whose currently popular eponymous typeface was largely inspired by the designs of this vital period in the history of the graphic arts.

GLOSSARY

Aktiengesellschaft	joint stock company	*Kursiv (also Cursiv)*	italic
Altenglisch	Old English	*large*	wide, expanded
Altromanisch	Old Romanesque	*Lateinisch*	Roman
ancien(ne)	old	*légère*	light
angulaires	angular	*lettres*	letters
Bambus	bamboo	*lettrines*	decorative initials
bâtarde(s)	bâtarde (a 17th-century French round hand)	*magere*	light
		Maschinenbau	machine tools
breit(e)	broad, expanded	*mit*	with
cancellaresca (Italian)	Chancery	*moderne*	modern
caractère	character	*Monogramme*	monograms
Cie (compagnie)	company	*Münchener*	of Munich
coulé(es)	cast (adj.)	*Nachf. (Nachfolger)*	successors
Cursiv (also Kursiv)	italic	*Neudeutsche*	New German
drei	three	*neu(e)*	new
Dreibuchstaben-Monogramme	monograms of three characters	*noir(e)*	black
Edelgotisch	noble Gothic	*Original(-)erzeugnis*	original product
Entwürfe	designs	*Pittoresk*	picturesque
étrusques	Etruscan	*Psalter-*	psalter (a book of psalms)
fantaisie(s)	fantasy(–ies)	*Reklameschrift*	advertising type
fette	bold	*romain*	Roman
Figuren	figures	*Romana*	Roman
Firmenschilder	business signs	*Römisch(e)*	Roman
Firmentafeln	business signs	*ronde*	round
Flemisch	Flemish	*Rundschrift*	roundhand
fonderie	foundry	*Schreibschrift*	script type
Fraktur	blackletter	*Schrift*	type
Française	French	*Schriftanwendungen*	applications of type
für	for	*Schriftenschilder*	signs in type
gezeichnet(e)	drawn	*Schriftgiesserei*	type foundry
Giesserei	foundry	*Signete*	colophons
G.m.b.H. (Gesellschaft mit beschränkter Haftung)	limited liability company	*Söhne*	sons
		Tedesca (Italian)	German
-gotisch	Gothic	*Titelschriften*	titling scripts
Grotesk	grotesque	*und (abbreviated u.)*	and
halbfette	demibold	*Venezia*	Venice
Hansa	Hanseatic League	*Venezianisch*	Venetian
Haus(es)	house	*vier*	four
Inserat	advertising	*von (abbreviated v.)*	of, by
Initialen	initials	*Vornamen*	first or Christian names
Jubiläums	jubilee	*Zierschrift*	ornate type
Kloster	cloister	*zweifarbige*	two-color
Künstler	artist		

CONTENTS

	PLATE		PLATE		PLATE
Mainzer Fraktur . . .	1	Blanchard light face . .	26	Neue Pittoresk	45
Offenbacher Reform . .	1	Blanchard Italic . . .	26	Franconia	45
Eckmann-Schrift . . .	2	Apollo	27	Tintoretto	46
Rundgotisch	3	Altenglisch	27	Constantia	46
Neudeutsche Schrift von		Neptun	27	Iris	46
O. Hupp	3	Columbus	28	Künstlergrotesk	47
Neudeutsch von G. Schiller	4	Ferdinand	28	Oceana	47
Hohenzollern	4	Cleopatra	29	Bambus-Grotesk . . .	48
Walthari	5	Gutenberg	29	Gloria	48
Globus, fette	6	Artistic Recherche . . .	29	Komet	48
Schwabacher, moderne fette	6	Huntsman	29	Artistik	49
Lemmen-Alphabet . . .	7	Harlech	30	Böcklin, Arnold . . .	49
Mikado, fette	8	Harrington	30	Multiform	50
Klostergotisch, magere .	8	Grasset Romain . . .	31	Secession, Reklameschrift	50
Dürer-Gotisch . . .	8	Modern Style	31	Quaint Roman Series . .	50
Behrens-Schrift	9	Fantaisie artistique . .	31	Herkules, Reklameschrift	51
Augsburger Schrift . .	10	Fantaisies étrusques . .	32	Thalia	51
Augsburger Initialen . .	10	Française legère von G.		Desdemona	52
Pretorian	11	Auriol	32	Edda	52
Tudor Black-Italic . . .	11	Fantaisie noire	32	Epitaph open Series . .	52
Schnorr, Vier Alphabete .	12	Venezia	33	Schreibschrift Romana .	53
Schnorr, Drei Alphabete .	12 a	Venezia, fette	33	Schreibschrift Venezianische	53
Baldur	13	Washington	34	Cancellaresca	53
Mira	13	Teutonic	34	Hispania	54
Edelgotisch	14	Dante	34	Sylphide	54
Siegfried	15	Römisch, breite halbfette	35	Hortensia, Zirkularschrift	54
Morris-Gotisch	16	Tedesca	35	Kalligraphia	55
Psaltergotisch	17	Alexandra	35	Inserat-Kursiv	55
Künstlergotisch	17	Erratic outline	36	Galathea	55
Münstergotisch	18	Skjald	36	Regina-Kursiv	56
Petrarka	18	Elefanta	37	Ideal-Kursiv, halbfette . .	56
Edison	18	Monopol Zierschrift . .	37	Hansa-Kursiv	56
Doublet Caractère . . .	19	Tip Top	38	Grotesk-Kursiv, zweifarbig	57
Lettres angulaires . . .	19	Teutonia	38	Quill Pen Script . . .	57
Lateinisch	20	Jenson	39	Römische Kursiv . . .	58
Lateinisch, halbfett . . .	20	Victoria	39	Altromanisch Kursiv . .	58
Inland Series	21	Samson	39	Commercial Script . . .	59
Becker-Series	21	Childs	40	Freehand Script . . .	59
Matthews-Series	22	Concordia	40	Manuscript	59
Edwards-Series	22	Enchoriales larges . . .	41	Figaro	59
Rogers-Series	23	Métropolitaines	41	Jenson Italic	60
Studley extended . . .	23	Cuban	42	Laclede	60
Gradl, M. J., Drei Alphabete	23 a	Grange	42	Harquil Series	61
Gradl, M. J., Zwei Alphabete	23 b	Ludgate	42	Hawarden Italic . . .	61
Virile open	24	Olympian	43	Bâtardes coulées . . .	62
Chaucer	24	Flemisch, condensed . .	43	Bâtardes	62
Santa Claus Initials . .	24	Flemisch, expanded . .	43	Ronde ancienne . . .	62
Culdee	24	Secession, halbfette . .	44	Gauloises	63
Robusta	25	Secession, magere . . .	44	Britannic Italic	63
Berolina	25	Negrita	44	Grasset-Italiques . . .	63
Eureka	25	Reclame	45	Pionier	64

	PLATE		PLATE		PLATE
Patent Reklame . . .	64	Römische Initialen, Gronau	79	Monogramme von Eugen	
Elzevier-Initialen		Grange Series von G. W.		Gradl	104–108
Breitkopf & Härtel .	65	Jones	80. 81	Monogramme von Julius	
Secession-Initialen . . .	65	de Vinne-Initialen . . .	82. 83	Klinkhardt	109–111
Münchener Renaissance-		Dorothy Series von G. W.		Monogramme von M. J.	
Initialen von Otto Hupp	66	Jones	84	Gradl	112–116
Renaissance-Initialen . .	67	Initialen von M. J. Gradl	85	Dreibuchstaben-Mono-	
Römische Initialen		Hohenzollern-Initialen .	86	gramme von H. Nowack	117. 118
Genzsch & Heyse .	67	Lettrines Renaissance . .	87	Vornamen von H. Nowack	119. 120
Walthari-Initialen . . .	68	Initialen von Eugène Bel-		Entwürfe von Lewis F. Day	121
Edelgotisch-Initialen . .	69	ville	87	Titelschriften v. P. Schnorr	122
Jubiläums-Initialen . . .	70	Initialen von Marcel Lenoir	88	Firmentafeln u. Schriften-	
Elzevier-Initialen, Flinsch	70	Initialen von Eug. Grasset	89	schilder von M. J. Gradl	123
Romanische Initialen . .	71	Initialen v. Maurice Dufrène	90. 91	Firmenschilder von P.	
Romana-Initialen . . .	71	Initialen v. H. de Waroquier	92. 93	Schnorr	124
Initialen mit Figuren von		Initialen v. William Morris	94	Entwürfe von Eugen Gradl	125. 126
Ethel Larcombe . .	72	Entwürfe von Bruce Rogers		Entwürfe von M. J. Gradl	127–131
Initialen von A. A. Turbayne	73	und Peter Schnorr .	95	Entwürfe von Franz Böres	132. 133
Initialen von Otto Eckmann	74	Entwürfe von J. V. Cissarz	96. 97	Entwürfe von G. M. Ell-	
Initialen von W. O. J. Nieu-		Entwürfe von Georges		wood	134. 135
wenkamp	75	Lemmen	98. 99	Entwürfe v. Bruno Mauder	136. 137
Initialen von M. J. Gradl	76	Entwürfe von George		Entwürfe v. Valentin Mink	138
Initialen von Behrens . .	77	Auriol	100. 101	Entwürfe v. G. M. Ellwood	139
Schwabacher-Initialen . .	78	Monogramme von J. G.		Moderne Titelschriften .	140
Initialen von M. J. Gradl	79	Schelter & Giesecke .	102. 103	Signete	141

INDEX

	PLATE		PLATE		PLATE
Alexandra	35	Blanchard, Italic . . .	26	Desdemona	52
Altenglisch	27	Böcklin, Arnold . . .	49	Dorothy Series, Initialen	84
Altromanisch-Kursiv . .	58	Böres, Franz, Schriftan-		Doublet Caractère . . .	19
Angulaires	19	wendungen	132. 133	Dufrène, Maurice, Initialen	90. 91
Apollo	27	Britannic Italic-Kursiv . .	63	Dürer-Gotisch	8
Artistic Recherche . . .	29	Cancellaresca, Schreib-		Eckmann-Schrift . . .	2
Artistik	49	schrift	53	Eckmann, O., Initialen .	74
Augsburger Schrift . .	10	Chaucer	24	Edda	52
Augsburger Initialen . .	10	Childs	40	Edelgotisch	14
Auriol George, Schriftan-		Cissarz, J. V., Schriftan-		Edelgotisch-Initialen . .	69
wendungen	100. 101	wendungen	96. 97	Edison	18
Baldur	13	Cleopatra	29	Edwards Series	22
Bambus-Grotesk . . .	48	Columbus	28	Elefanta	37
Bâtardes, Rundschrift . .	62	Commercial Script, Schreib-		Ellwood, G. M., Schrift-	134. 135
Bâtardes coulées, Rund-		schrift	59	anwendungen . . .	139
schrift	62	Concordia	40	Elzevier-Initialen	
Becker Series	21	Constantia	46	von Breitkopf & Härtel	65
Behrens-Schrift	9	Cuban	42	Elzevier-Initialen v. Flinsch	70
Behrens-Initialen . . .	77	Culdee	24	Enchoriales larges . . .	41
Belville, Eugène, Initialen	87	Dante	34	Epitaph open Series . .	52
Berolina	25	Day, Lewis, F., Schrift-		Erratic outline	36
Blanchard, light face . .	26	anwendungen . . .	121	Eureka	25

	PLATE		PLATE		PLATE
Fantaisie artistique . . .	31	Künstler-Grotesk . . .	47	Reclame	45
Fantaisies Etrusques . .	32	Laclede, Kursiv	60	Regina-Cursiv	56
Fantaisie noire	32	Larcombe, E., Initialen .	72	Renaissance-Initialen . .	67
Ferdinand	28	Lateinisch	20	Robusta	25
Figaro, Schreibschrift . .	59	Lateinisch, halbfett . .	20	Rogers Series	23
Flemisch condensed . .	43	Lemmen-Schrift	7	Rogers, Bruce, Schriftan-	
Flemisch expanded . .	43	Lemmen, Georges, Schrift-		wendungen	95
Française légère von G.		anwendungen . . .	98. 99	Romana-Initialen . . .	71
Auriol	32	Lenoir, Marcel, Initialen .	88	Romana-Schreibschrift .	53
Franconia	45	Lettrines, Renaissance .	87	Romanische Initialen . .	71
Freehand Script, Schreib-		Ludgate	42	Römisch, breite halbfette	35
schrift	59	Mainzer Fraktur . . .	1	Römische Initialen von	
Galathea, Kursiv . . .	55	Manuscript, Schreibschrift	59	Genzsch & Heyse .	67
Gauloises, Kursiv . . .	63	Matthews Series . . .	22	Römische Initialen von	
Globus, fette	6	Mauder, Bruno, Schrift-		Gronau	79
Gloria	48	anwendungen . . .	136. 137	Römische Kursiv . . .	58
Gradl, Eug., Monogramme	104–108	Métropolitaines	41	Ronde ancienne . . .	62
Gradl, Eugen, Schriftan-		Mikado, fette	8	Rundgotisch	3
wendungen	125. 126	Mink, Valentin, Schrift-		Samson	39
Gradl, M. J., drei Alphabete	23 a	anwendungen . . .	138	Santa Claus Initials . .	24
Gradl, M. J., zwei Alphabete	23 b	Mira	13	Schnorr, Peter, Vier Alpha-	
Gradl, M. J., Firmenschilder	123	Modern Style	31	bete	12
Gradl, M. J., Initialen . .	76.79.85	Monogramme von Julius		Schnorr, Drei Alphabete .	12 a
Gradl, M. J., Monogramme	112–116	Klinkhardt	109–111	Schnorr, Peter, Schriftan-	95. 122
Gradl, M. J., Schriftanwen-		Monogramme von Schel-		wendungen	124
dungen	127–131	ter & Giesecke . . .	102. 103	Schwabacher, mod. fette	6
Grange	42	Monopol	37	Schwabacher-Initialen . .	78
Grange Series, Initialen .	80–81	Morris-Gotisch	16	Secession, magere . . .	44
Grasset, Italiques, Kursiv	63	Morris, William, Initialen,		Secession, halbfette . .	44
Grasset, Eugène, Initialen	89	zwei Alphabete . .	94	Secession - Reklameschrift	50
Grasset, Romain . . .	31	Multiform	50	Secessions-Initialen . .	65
Grotesk-Kursiv, zweifarb.	57	Münchener Renaissance-		Siegfried	15
Gutenberg	29	Initialen von O. Hupp	66	Signete	141
Hansa-Kursiv	56	Münster-Gotisch . . .	18	Skjald	36
Harlech	30	Negrita	44	Studley, Extended . . .	23
Harquil series	61	Neptun	27	Sylphide, Cursiv . . .	54
Harrington	30	Neudeutsch (O. Hupp) von		Tedesca	35
Hawarden, Italic, Kursiv .	61	Genzsch & Heyse .	3	Teutonia	38
Herkules	51	Neudeutsch (G. Schiller)		Teutonic	34
Hispania, Kursiv . . .	54	von C. F. Rühl . .	4	Thalia	51
Hohenzollern	4	Nieuwenkamp, W. O. J.,		Tintoretto	46
Hohenzollern-Initialen .	86	Initialen	75	Tip Top	38
Hortensia - Zirkularschrift,		Nowack, H., Dreibuch-		Titelschriften, moderne	
Kursiv	54	staben-Monogramme .	117. 118	Anwendungen . . .	140
Huntsman	29	Nowack, H., Vornamen .	119. 120	Tudor Black, Italic . .	11
Ideal-Kursiv, halbfette .	56	Oceana	47	Turbayne, A. A., Initialen	73
Jenson	39	Offenbacher Reform . .	1	Venezian. Schreibschrift .	53
Jenson, Italic, Kursiv . .	60	Olympian	43	Venezia	33
Inland Series	21	Patent-Reclame	64	Venezia, fette	33
Inserat-Kursiv	55	Petrarka	18	Victoria	39
Iris	46	Pionier	64	de Vinne-Initialen . . .	82. 83
Jubiläums-Initialen . . .	70	Pittoresk, neue	45	Virile open	24
Kalligraphia, Kursiv . .	55	Pretorian	11	Walthari	5
Kloster-Gotisch, magere .	8	Psalter-Gotisch	17	Walthari-Initialen . . .	68
Komet	48	Quaint Roman Series . .	50	Waroquier, H. de, Initialen	92. 93
Künstler-Gotisch . . .	17	Quill Pen script, Cursiv	57	Washington	34

A B C D E F G H I K
L M N O P Q R S T U
a b c · V W X Y Z · d e f
g h i k l m n o p q r f s t u v
1 2 3 4 5 · w x y z · 6 7 8 9 0
Amsterdam · Mandoline
Robinson · Commiſſion

A B C D E F G H I K L M N O
∴ P Q R S T U V W X Y Z ∴
INSTRUMENT · BRUXELLES
Mendelssohn · Accord · Restaurant
a b c d e f g h i k l m n o p q r s t u v w x y z
1 2 3 4 5 6 7 8 9 0

PLATE 1

ABCDDEFG
HIJJKLM
NOPQRSTT
UVWXYZIVX
1234567890
abcdefghijkl
mnopqrſstuvw
Plan · x y z · Club
Stanley · Gabriel
RUDELSBURG

PLATE 2

ABCDEFGHIJKLMN
OPQRSTUVWXY3
BRIGADE : NICKEL
abcdefghijklmnopqrſs
tuvw1234567890xy33
Agram . Dublin . Reval
EVA.METROPOLE

«NEUDEUTSCHE SCHRIFT» · SCHRIFTGIESSEREI GENZSCH & HEYSE · HAMBURG

ABCDEFGHIJKLM
NOPQRSTUVWXYZ
abcdefghiklmn
opqrſstuvwxyz
12345 · Virginie · 67890
Romeo · Illumination
China · Pelican · Utopia

PLATE 3

ABCDEFGHIJKLM
NOPQRSTUVWXY
ZANSIBAR : LESBOS
abcdefghijklmnop
qrsſtuvwxyz ch ck ſʒ ŧ
Note 12345678 Eros

ABCDEFGHIJKLMN
OPQRSCTUUWXYZ
LAWN-TENNIS-MATCH
Amazone · Rigi · Palissade
abcdefghijklmnopqr
sſtuvwxyz ch ck ſt ʒ ŧ
1234567890

PLATE 4

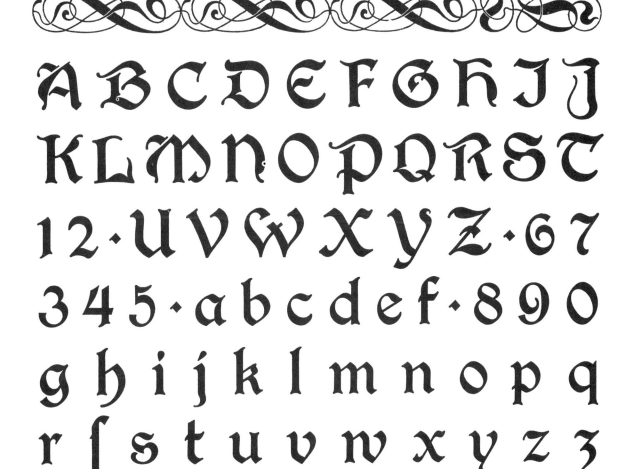

A B C D E F G H I J
K L M N O P Q R S T
1 2 · U V W X Y Z · 6 7
3 4 5 · a b c d e f · 8 9 0
g h i j k l m n o p q
r ſ s t u v w x y z z

Leopold, Pergament
Manchester, Gazelle
Fandango, Benjamin
Cascade, Aluminium

PLATE 5

A B C D E F G H I J K L
M N O P Q R S T U V W
1 2 3 4 5 · X Y Z · 6 7 8 9 0
a b c d e f g h i j k l m n o p
q r s t u · YOST · v w x y z
BRUTUS · MOB · ALBERT
Kodak, Echo, Venus, Pastel
Dover, Cervantes, Mantua

«MODERNE FETTE SCHWABACHER» · SCHRIFTGIESSEREI OTTO WEISERT · STUTTGART

A B C D E F G H I J K L
M N O P Q R S T U V
1 2 3 · W X Y Z · 6 7 8
4 5 · Cook · Bach · 9 0
a b c d e f g h i j k l m
n o p q r s t u v w x y z

PLATE 6

ARGOS

1234567890

ABCDDEF

GHIJKLLMN

OPP2RRS

TUVWXYZ

Bellérophon ab
cdefghijklmnop
qrstvwxyz Juli

PLATE 7

ABCDEFGHIJKLMNOPQRSTUV
BOSPORUS · WXYZ · HIMALAYA
12 abcdefghijklmnopqrstuvwxyz 67
345 · Passage · Toilette · Ouverture · 890
Agamemnon · Iphigenia · Klytemnaestra

ABCDESGHIJKLMNOPQRSTUV
MOLIERE · WXYZ · ROUSSEAU
abcdefghijklmnopqrſstuvwxyz
12345 · Limoges · Meissen · 67890
Wedgewood · Rouen · Ludwigsburg

ABCDEFGHIJKLMNOPQR
12345 · STUVWXYZ · 67890
abcdefghijklmmnnopqrstuv
PAGANINI · wxyz · BERGAMO
Andromache · Hector · Achilles

PLATE 8

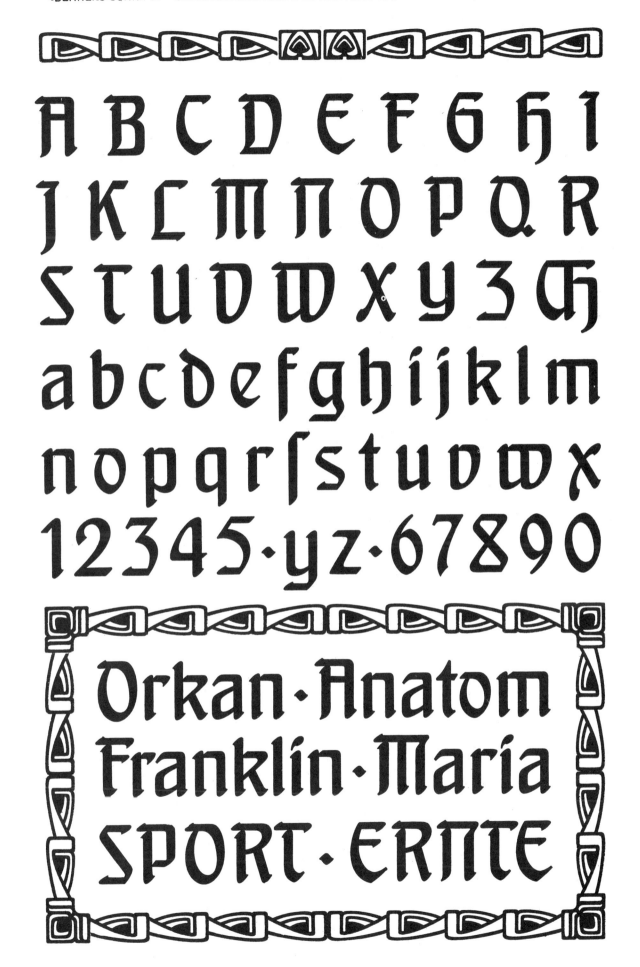

PLATE 9

A B C D E F G H I J K L M
N O P Q R S T U V W X Y Z
a b c d e f g h i j k l m n o p q r s t
1 2 3 4 5 · u v w x y z · 6 7 8 9 0
∴ Cotillon · Pantomime ∵
SPARTA · TUNIS · DAUDET
Tolstoij · Van de Velde · Dewet
Roberts · Kimberley · Themse
Sadowa · Olive · Zarathustra

AUGSBURGER INITIALEN.

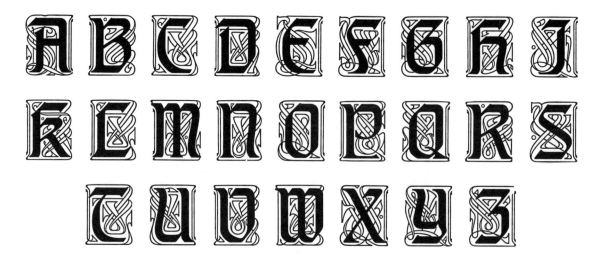

PLATE 10

ABCDEFGHIJ
KLMNOPQRST
12UVWXYZ67
345 Mexico 890
abcdefghijkl
mnopqrstuvw
WHIP . xyz . ABEL

ABCDEFGHJK
LMNOPQRST
12UVWXYZ67
345 . Crinoline . 890
abcdefghijklmn
opqrstuvwxyz
Scene . Mark . Porto

PLATE

ABCDEFG
HIJKLMN
OPQRSTU
VWXYZ

ABCDEFG
HIJKLMN
OPQRSTU
VWXYZ

ABCDEFGH
JKLMNOPQ
RSTUVWZ

ABCDEFGHIJ
KLMNOPQR
STUVWXYZ

1 2 3 4 5
6 7 8 9 0
1 2 3 4 5
6 7 8 9 0

ABCDE ABCD
FGHIJ EFGH
KLMN JKLMN
OPQR OPQR
STUV SGUD
WXYZ WXYZ

ABCDEFGH
IJRLMNOP
QRSTUVW
XYZ abcdefghik
lmnopqrsfuuwxyz&

ABCDEFGHIJKLMN
OPQRSTUVWXYZ
abcdefghijklmnop
qrstuvwxyz
1234567890

ABCDEFGHIJ
KLMNOPQRST
12·TUVWXYZ·34
abc567890 def
ghijklmnopqrstu
vwxyz ch ß

PLATE 13

ABCDEFGHIJKL

MNOPQRSTUVW

abcdef . XYZ . ghijkl

mnopqrsſtuvwxyz

JOHANNESBURG

NATION . MICADO

Birmingham . Tunis

Hugo . Carmen . Plan

1234567890

PLATE 14

ABCDEFGHIJK
LMNOPQRSTU
VWXYZ.GOBELIN
abcdefghijkd
lmnopqrsſfuv
TYPE.wxyz.ROSE
MINERVA-SCYLLA
Cicerone. Fandango
1234567890

PLATE 15

ABCDEFGHI

JKLMNOPQR

STUVWXYZ

LUXEMBURG

Ibsen·Aquarium

Napoléon · Paris

abcdefghijklmn

opqrſstuvwxyz

1234567890

PLATE 16

A B C D E F G H J K
L M N O P Q R S T
1 2 · U V W X Y Z · 6 7
3 4 5 · Aluminium · 8 9 0
a b c d e f g h i j k l m n
o p q r s t u v w x y z

‹KÜNSTLER-GOTISCH› · BENJAMIN KREBS NACHF. FRANKFURT A. M.

A B C D E F G H I J
K L M N O P Q R S T
1 2 · T U V W X Y Z · 6 7
3 4 5 · Birmingham · 8 9 0
a b c d e f g h i j k l m n
o p q r s t u v w x y z
Cretonne · Eva · Transport

PLATE 17

ABCDEFGHIJKLMNOPQR
12345 · STUVWXYZ · 67890
abcdefghijklmnopqrsſtuv
GERANIUM · wxyz · TENNYSON
Decoration · Baltimore · Anacreon

ABCDEFGHIJKLMNOPQRS
12345 · TUVWXYZ · 67890
abcdefghijklmnopqrstu
ABRAHAM · vwxyz · URUGUAY
BOCCACCIO · MARS · SHEFFIELD
Bacchante · Haendel · Gentleman

ABCDEFGHIJKLM
NOPQRSTUVWXYZ
abcdefghijklmnopqrstu
12345 · vwxyz · 67890
Rooseveldt, Vautier, Feodorowna
Carnegie, Elzevier, Bouquet

PLATE 18

ABCDEFGHIJ
KLMNOPQRS
TUVWXYZ
1234567890
FAUST, PLUTO
a a b c d e f g h i j k l m
n o p q r s t u v w x y z

‹LETTRES ANGULAIRES› · SCHRIFTGIESSEREI CH. BEAUDOIRE & Cie · PARIS

ABCDEFGHIJKLM
NOPQRSTUVWX
12345 · YZ · 67890
a b c d e f g h i j k l m n o
æ p q r s t u v w x y z œ
Eva. FORUM. Spa

PLATE 19

ABCDEFGHIJKL
MNOPQRSTUVW
12345·XYZ·67890
Diana·YORK·Adam
abcdefghijklmn
∴opqrstuvwxyz∴

ABCDEFGHIJKLMN
::OPQRSTUVWXYZ::
Tivoli.ORLEANS.Gogol
abcdefghijklmnopqrst
12345::uvwxyz::67890

PLATE 20

ABCDEFGHIJKL
MNOPQRSTUVW
12345XYZ67890
abcdefghijklm
nopqrstuvwxyz
ESTREMADURA
GIBRALTAR
Recitation

ABCDEFGHIJKL
MNOPQRSCTUV
12345WXYZ67890
abcdefghijklmnopq
rstuvwxyz

PLATE 21

ABCDEFGHIJKL
MNOPQRSTUVW
1234·XYZ·6789
5·ORATORIUM·0
KINDERGARTEN
abcdeefghbijklm
nnopqrstuvwxyz

‹EDWARDS SERIES› · INLAND TYPE FOUNDRY · SAINT LOUIS U. S. A.

ABCDEFGHIJKL
MNOPQRSTUVW
1234·XYZ·6789
5·NICARAGUA·0
abcdefghijklm
nopqrstuvwxyz

PLATE 22

ABCDEFGHIJK
LMNOPPQRRSS
1 TUVWXYZ 6
2 aabcdefghijk 7
3 lmmnnopqr 8
4 stuuvwxyz 9
5 PORTUGAL 0

ABCDEFGHIJKLM
NOPQRSTUVWXY
12345 Z 67890
Beethoven, Wagner
abcdefghijklmnopq
rstuvwxyz
GUTENBERG
FRANKFURT

PLATE 23

ABCDEFGHIJKC
MNOPQRSTUVW
XYZ·1234567890

ABCDEFGHJ
IKLMNOPQ
RSTUVWXYZ

ABCDEFGHIJKLMN
OPQRSTUVWXYZ mig
1903

ABCDEFG
HIJKLMNO
PQRSTUV
W ivoz345 XYZ
MiG

ABCDEFG
HIJKLMNH
OPQRSTÜ
UVWXYZ 6789

PLATE 23B

ABCDEFGHIJKLMNOPQ
1234.RSTUVWXYZ.6789
5. Dover, Florian, Sevilla, Michael . O
abcdefghijklmnopqrstu
HEIDELBERG · vwxyz · CASSANDRA

"CHAUCER" · AMERICAN TYPE FOUNDERS' CO. · PHILADELPHIA

ABCDEFGHIJKLMNOPQRS
12345 . TUVWXYZ . 67890
abcdefghijklmnopqrstuvw
Priamus, Instinct . xyz . Photogravure, Statue

"SANTA CLAUS" INITIALS · AMERICAN TYPE FOUNDERS' CO. · PHILADELPHIA

ABCDEFGHIJKLMNOPQR
ABOUKIR . STUVWXYZ . IVANHOE
MARGARINE, ALBERT, CONTUSION

"CULDEE" · AMERICAN TYPE FOUNDERS' CO. · PHILADELPHIA

ABCDEFGHIJKLMNOP
123 . QRSTUVWXYZ . 678
45. Rossini, Florida, Canova, Illinois . 90
abcdefghijklmnopqrstuv
RADICAL ❖ wxyz ❖ MILLION

PLATE 24

ABCDEFGHIJKLMNO
12 · PQRSTUVWXYZ · 67
345 · abcdefghij · 890
klmnopqrstuvwxyz
Situation · Cosmos · Aluminium
RISOTTO · ORANGE · POLENTA

‹BEROLINA› · W. GRONAU'S SCHRIFTGIESSEREI · BERLIN-SCHÖNEBERG

ABCDEFGHIJKLMNOPQR
12345 · STUVWXYZ · 67890
abcdefghijklmnopqrstuvw
BORDEAUX · xyz · ABERDEEN

‹EUREKA› · B. KREBS NACHFOLGER · FRANKFURT A. M.

ABCDEFGHIJKLMNO
12 · PQRSTUVWXYZ · 67
345 · ABCDEFGHIJ · 890
KLMNOPQRSTUVWXYZ
SENEGAL · TRADE MARK · WEIMAR

PLATE 25

ABCDEFGHIJKL
MNOPQRRSTUV
12345 WXYZ 67890
aabcdefghhijklmm
nnopqrsstuvwxyz
MUSEUM·BOSTON

AABCDEFGHI
JKLMNOP2RR
STTUVWXYZ
CORPORATION
abcdefghijklmno
pqrfstuvwxyz
1234567890

PLATE 26

ABCDEFGHIJKLMN
OPQRSTUVWXYZ
abcdefghijklmnopqrst
12345 · uvwxyz · 67890

ABCDEFGHIJKLMN
OPQRSTUVWXYZ
abcdefghijklmnopqrstuv
12345 · wxyz · 67890

ABCDEFGHIJKLMN
OPQRSTUVWXYZ
abcdefghijklmnopqrst
12345 · uvwxyz · 67890

Ventilation · Manchester

PLATE 27

ABCDEFGH
IJKLMNOPQ
RSTUVWXYZ
abcdefghijkl
mnopqrstuvw
123 æ xyz œ 678
45. Worcester. 90

ABCDEFGHIJK
LMNOPQRSTU
12345=VWXYZ=67890
abcdefghijklmnopqr
Dollar. stuvwxyz. Bitter

PLATE 28

A B C D E F G H I J K L M N O P Q R S
1 2 3 4 5 - J U V W X Y Z - 6 7 8 9 0
a b c d e f g h i j k l m n o p q r s t u v w x y z
Ghetto, Ischia, CAMPANILE, Domino, Punch
Faience, Reynolds, Lampion, Wellington, Eros

A B C D E F G H I J K L M N O P Q R S
1 2 3 4 5 - T U V W X Y Z - 6 7 8 9 0
a b c d e f g h i j k l m n o p q r r s s t u v w x y z
Fandango, Victoria, DELPHI, Lecture, Tradition,
Aphrodite, Martin, Canterbury, Watteau, Samuel

A B C D E F G H I J K L M N O P Qu R S
1 2 3 4 5 - T U V W X Y Z - 6 7 8 9 0
a b c d e f g h i j k l m n o p q r s t u v w x y z
Calcutta, Paul, Milton, ALBERT, Pension, Henry, Glasgow
Relief, Farnese, Original, Philadelphia, Stanley, Loubet, Tivoli

A B C D E F G H I J K L M N O P Q R S
1 2 3 4 5 - T U V W X Y Z - 6 7 8 9 0
a b c d e f g h i j k l m n o p q r s s t u v w x y z
Marconi, Correggio, Liebig, Ration, Hogarth
PALLAS, AMATEUR, FAKIR, GENERAL

PLATE 29

AABCDEFGHIJKLM
NOPQRSTUVWXYZ
abcdefghijklmnopqr
12345stuvwxyz67890
Adam, Gainsborough, Metz
OSTENDE . CAMBRIDGE

ABCDEFGHIJKL£
MNOPQRSTUVWX
12345 - YZ - 67890
abcdefghijklmnopq
rstuv.EDISON.wxyz
Forum, Anemone, Venus
Gotha, Kentucky, Record
SHEFFIELD . DUBLIN

PLATE 30

ABCDEFGHIJKLM
NOPQRSTUVWXYZ
abcdefghijklmnopqrst

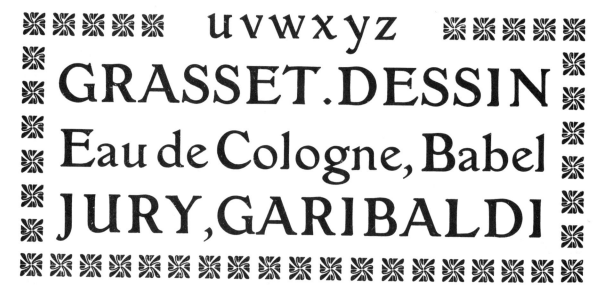

uvwxyz

GRASSET.DESSIN

Eau de Cologne, Babel

JURY, GARIBALDI

ABCDEFGHIJKLM
NOPQRSTUVWXYZ

ABCDEFGHIJKLMNOP
abcQRSTUVWXYZdef
ghijklmnopqrstuvwxyz
CHARLES.JOSEPHINE

PLATE 31

ABCDEFGHIJKLMNOP
QRSTU · FELIX · VWXYZ
abcdefghijklmnopqrstuv
RELIGION · wxyz · CHOLERA
International, Bruno, Reval, Humbert

ABCDEFGHIJKLMNOPQRSTUV
TURBINE · WXYZ · MENTONE
abcdefghijklmnopqrstuvwxyz
12345 · Montreux, Service · 67890
Utrecht · Cambridge · Gibraltar

ABCDEFGHIJKLM
NOPQRSEUVWXYZ
abcdefghijklmnopqrstuv
Tintoretto · wxyz · Boulevard

PLATE 32

AÆBCDEFGHIJKLM
NOPQRSTUVWXYZ
aɑbcdefghijklmno
∴opqrstuvwxyyz∴
12345·Faust·67890
Monument · Souvenir
DOMENICO.MEMENTO

AÆBBCDEFFGHIJKLM
MNOOPQRRSTUVWX
BÆRON · YZ · ÆDONIS
CAROLINE :: MANDARIN
Montenegro · Ghirlandajo
aɑbcdefghijklmno
opqrstuvwxyyz
1234567890

PLATE 33

ABCDEFGHIJKLMNO
12 PQRSTUVWXYZ 67
345 abcdefghijklmn 890
ABEL· opqrstuvwxyz · MINE
Bretagne Combination Sardine

‹TEUTONIC› · MILLER & RICHARD · EDINBURGH

ABCDEFGHIJKLMNOPQRSTUV
TROCADERO · WXYZ · BONAPARTE
abcdefghijklmnopqrsstuvwxyz
12345 · Beatrix, Arsenal · 67890
Santander, Conservation, Guillotine

‹DANTE› · ORIGINALERZEUGNIS VON SCHELTER & GIESECKE · LEIPZIG

ABCDEFGHIJKLMNOPQR
12345·STUVWXYZ·67890
abcdefghijklmnopqrstuvw
CORPULENT· xyz ·ETIQUETTE
Augustin · Buenos Ayres · Waterloo

PLATE 34

ABCDEFGHIJK
LMNOPQRSTUV
WX·ARTHUR·YZ
Banner·Richard
abcdefghijklm
nopqrstuvwxyz
1234567890

ABCDEFGHIJKLM
NOPQRSTUVWXYZ
abcdefghijklmnopqrs
12345 · tuvwxyz · 67890

ABCDEFGHIJKL
MNOPQRSTUVW
12345 XYZ 67890

ABCDEFGHIJK
LMNOPQRSTU
123·VWXYZ·678
45 Bivouac, Villa 90
abcdefghijklm
nopqrstuvwxyz
HOUSE, CANADA

"SKJALD" · AMERICAN TYPE FOUNDERS' CO. · PHILADELPHIA

ABCDEFGHIJKL
MNOPQRSTUVW
12345 ∘ XYZ ∘ 67890
abcdefghijklmn
-opqrstuvwxyz-
David. Amazon. Probe
Edina. Index. Bulwark

PLATE 36

AABCDEFGHIJKLM

MNOPQRSSTUVW

12345 · XYZ · 67890

MEDUSE : ROUTINE

Note · Valparaiso · Paul

abcdeefghijklmmn

:: opqrstuvwxyz ::

ZIERSCHRIFT ‹MONOPOL› · EDUARD SCHOLZ · WIEN

ORANGE.BOSTON.SULTAN

FLIRT.HARMONIUM.ADIEU

ABCDEFGHIJKLMNO

· PQRSTUVWXYZ ·

· 1234567890 ·

PLATE 37

ABCDEFGHIJKLMN
OPQRSTUVWXYZ
abcdefghijklmno
pqrstuvwxyz
1234567890

‹TEUTONIA› · ROOS & JUNGE · OFFENBACH

ABCDEFGHIJKLM
NOPQRSTUVWXYZ
abcdefghijklmno
pqrstuvwxyz
1234567890

PLATE 38

ABCDEFGHIJKLMNOP
123 QRSTUVWXYZ 678
45 abcdefghijklmnopqrstu 90
BERLIN vwxyz RACINE
Confucius · Islam · Mahomed

ABCDEFGHIJKLM
NOPQRSTUVWXYZ
abcdeffghhijklmmnnop
123 · qrsstuvwxyz · 678
45 PIANO FIUME 90
Marine Ostade Rauch

ABCDEFGHIJKLMNOPQR
12345 STUVWXYZ 67890
abcdefghijklmnopqrstuvw
MERODE · xyz · THOMAS
Ramses Reporter Central

PLATE 39

ABCDEFGHIJKLM
NOPQRSTUVWXYZ
abcdefghijklmnop
12 qrstuvwxyz 67
345=Vision, Tunnel=890
COMPETENT, BARRY

ABCDEFGHIJKLMNOPQR
12345·STUVWXYZ·67890
abcdefghijklmnopqrstu
HELVETIA · vwxyz · DOCUMENT
Calame · Renaissance · Gladstone
Passage, DonJuan, Gotha, Lenbach

PLATE 40

ABCDEFGHI
JKLMNOPQR
STUVWXYZ
1234567890
·REVOLUTION·
·WASHINGTON·
·MANET·DAVID·

‹METROPOLITAINES› · SCHRIFTGIESSEREI BERTHIER & DUREY · PARIS

ABCDEFGHIJKLM
NOPQRSTUVWXYZ
1234567890
NERO·GERMANIA·ZOLA
PLUTO·SHAKESPEARE
IMPERATOR·OSTENDE
HOLBEIN·LEO·GŒTHE

PLATE 41

CUBAN» MILLER & RICHARD · EDINBURGH

ABCDEFGHIJKLM
NOPQRSTUVWXYZ
12345 CUBA 67890
VERANDA, DESSERT
ARGUMENT, BELLA

GRANGE» MILLER & RICHARD · EDINBURGH.

ABCDEFGHIJKLM
MNNOPQRSTTUVW
12345 ❧XYZ❧ 67890
JERUSALEM, ORLEANS
CALIGULA, EXPEDITION

LUDGATE» MILLER & RICHARD · EDINBURGH.

ABCDEFGHIJKLMNOP
123·QRSSTUVWXYZ·678
45·PARDON, NEWTON·90
abcdefghijklmnopqrst
Jupiter, uvwxyz, Havana
Boulevard, Ibis, Remington

PLATE 42

ABCDEFGHIJKLMN
OPQRSTUVWXYZŒ
abcdefghijklmnopqrst
12345 · uvwxyz · 67890
Moment, Commode, Stock
RELIGION.CHARLOTTE

ABCDEFGHIJKLMNOPQRS
12345 · TUVWXYZ · 67890
GRATIS · CIGARETTE · EDISON
BISQUIT · ROBERT · DIRECTOR

ABCDEFGHIJKLMN
OPQRSTUVWXYZÆ
abcdefghijklmnopqrst
12345 · uvwxyz · 6789
Cousin, Garibaldi, Pension
CASINO.HAMLET.JURY

PLATE 43

AABCDEFGHHIJKLM
NOPQRSSTUVWXYZ
abcdeefghijklmnopqrsst
12345 · uvwxyz · 67890

AABCDEFGHHIJKLMNNOPQR
12345=SSTUVWXYZ=67890
abcdeefghijklmnopqrsstuvwxyz

AABCDEFGHHH
IJKLMMNNOPQR
SSTTUUVWXYZ
abcdefghhijklm
nopqrsstuvwxyz
1234567890

PLATE 44

ABCDEFGHIJKLMNOPQRSTUVWXYZ

12 · abcdefghijklmnopqrstuvwxyz · 67

345 · NATIONAL · DON QUICHOTTE · 890

Conserve · Discretion · Transport · Express

A B C D E F G H I J K L M N O P

Q R S T U · ANANAS · V W X Y Z

ILLUSTRATION · JAVA · BELLEVUE

a b c d e f g h i j k l m n o p q r

s t u v · 1 2 3 4 5 6 7 8 9 0 · w x y z

ABCDEFGHIJKLLMMN

123·OPQRSTUVWXYZ·678

45 · abcdefghijklmnopqrst · 90

MONACO·uvwxyz·QUATRO

Finance · Isola bella · Toscana

PLATE 45

ABCDEFGHI
JKLMNOPQ
RSTUVWXYZ
abcdefghijklm
nopqrstuvwxyz
1234567890

‹CONSTANTIA› · BAUER & CO., STUTTGART & H. BERTHOLD · BERLIN

ABCDEFGHIJKLM
NOPQRRSSTUVW
12345 · XYZ · 67890
abcdeefghijklmn
nopqrsstuvwxyz

ABCDEFGHIKLMNOPQRST
12345 · UVWXYZ · 67890

PLATE 46

ABCDEFGGHH
iJKLMNOOPQRR
SSTUVWXYZCHLA
LT1234567890TH
GLADIATOR · CHARADE
HERDER · GOTTHARD

AABCCDEFFGH
HIJJKKLLMNOPP
QRRSTTUVWXYZ
Santos · Darwin · Bristol
aabcddeefghhijkk
lmmnnopqrstuvwxyz

PLATE 47

ABCDEFGHIJKLMNOPQ
abc · RSTUVWXYZ · def
ghijklmnopqrstuvwxyz
12345 · CONGO · 67890
Supplement · Thorwaldsen

ABCDEFGHIJKLMNOP
ab · QRSTUVWXYZ · cd
: efghijklmnopqrstuvwxyz :
12345 · ELEPHANT · 67890
Service · Influenza · Bajaccio

ABCDEFGHIJKLMNOP
aa · QRSTUVWXYZ · bc
defghijklmnopqrstuvwxyz
12345 · Versailles · 67890

PLATE 48

A A B C D E F F G H H I
J K K L M M N N O P Q
R R S T T U U V W W X
1 2 3 4 5 : Y Z : 6 7 8 9 0
Hastings · Nottingham
a b c d e f g h i j k l m n
o p q r s s t u v w x y z

«ARNOLD BÖCKLIN» · SCHRIFTGIESSEREI OTTO WEISERT · STUTTGART

A B C D E F G H I J K L
M N O P Q R S T U W
1 2 3 4 5 6 · X Y Z · 7 8 9 0
a b c d e f g h i j k l m
n o p q r s t u v w x y z
Stuttgart · Heilbronn

PLATE 49

ABCDEFGHIJKLM
NOPQRSTUVWXYZ
✻ 12345 ✻ 67890 ✻
JOCKEY ✻ SULTAN
BRISTOL · PENSION

REKLAMESCHRIFT «SECESSION» · SCHRIFTGIESSEREI EDUARD SCHOLZ · WIEN

ABCDEFGHIJKLMN
OPQRSTUVWXYZ
abcdefghijklmnopqr
stuv · GOUNOD · wxyz
Copernicus · Newton

«QUAINT ROMAN SERIES» · CENTRAL TYPE FOUNDRY · SAINT LOUIS · U. S. A.

ABCDEFGHIJKL
MNOPQRSTUVWX
12345 · YZ · 67890
abcdefghijklmnopqr
stuv · Mozart · wxyz

PLATE 50

ABCDEFGHIJKLM
NOPQRSTUVWX
abcde · yz · fghikl
mnopqrstuvwxyz
12345 · VASE · 67890
Humboldt · Budapest

«THALIA» · ORIGINAL-ERZEUGNIS VON SCHELTER & GIESECKE · LEIPZIG

ABCDEFGHIJKLM
OPQRSTUVWXYZ
abcdefghijklmnopqrst
uvw · 1234567890 · xyz
Morgan, Tilly, Offenbach,
Rubens, Fabrication

PLATE 51

ABCDEFGHIJKLMN
OPQRSSTUVWXYZ
12345 · ISAAC · 67890
ACHMED, LINOLEUM
DAVID, CHROMO, TYPE

AABCDEEFGHIJK
LMNOPQRSTZUV
WX·1234567890·YZ
AMATEUR, DICKENS
RECORD, VICTOR

ABCDEFGHIJKLMNO
Y . PQRSTUVWXYZ . Y
Y . ROCKEFELLER . Y
Y . SEDAN-BYRON . Y

PLATE 52

‹SCHREIBSCHRIFT ROMANA› · BAUER & CO · STUTTGART & H. BERTHOLD · BERLIN

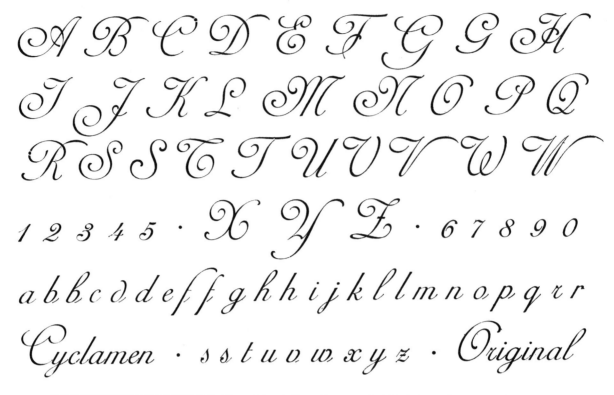

$A\ B\ C\ D\ E\ F\ G\ G\ H$

$I\ J\ K\ L\ M\ N\ O\ P\ Q$

$R\ S\ S\ T\ U\ V\ W\ W$

$1\ 2\ 3\ 4\ 5 \cdot X\ Y\ Z \cdot 6\ 7\ 8\ 9\ 0$

$a\ b\ b\ c\ d\ d\ e\ f\ f\ g\ h\ h\ i\ j\ k\ l\ m\ n\ o\ p\ q\ r\ r$

Cyclamen · s s t u v w x y z · Original

‹VENETIANISCHE SCHREIBSCHRIFT› · SCHRIFTGIESSEREI GENZSCH & HEYSE · HAMBURG

$A\ B\ C\ D\ E\ F\ G\ H\ H\ I\ J\ K\ L$

$M\ N\ O\ P\ Q\ R\ S\ T\ T\ U\ V\ W$

$a\ b\ b\ c\ d\ d\ d\ e\ f\ g \cdot X\ Y\ Z \cdot h\ h\ i\ j\ k\ l\ m\ n\ o\ p$

$1\ 2\ 3\ 4\ 5 \cdot q\ r\ s\ t\ t\ u\ v\ w\ x\ y\ z\ z \cdot 6\ 7\ 8\ 9\ 0$

Venezuela · Requiem · Testament

‹CANCELLARESCA› · ORIGINALERZEUGNIS VON SCHELTER & GIESECKE · LEIPZIG

$A\ B\ C\ D\ E\ F\ G\ H\ I\ J\ K\ L$

$M\ N\ O\ P\ Q\ R\ S\ T\ U\ V\ W\ X$

$a\ b\ c\ d\ e\ f\ g\ h\ i\ j \cdot Y\ Z \cdot k\ l\ m\ n\ o\ p\ q\ r\ s$

$1\ 2\ 3\ 4\ 5 \cdot t\ u\ v\ w\ x\ y\ z \cdot 6\ 7\ 8\ 9\ 0$

ABCDEFGHIJKLM
NOPQRSTUVWXYZ
MENELIK · HAARLEM
abcdefghijklmnopqrstuvwxyz
12345 · Philadelphia · 67890
Fahrenheit · Glasgow · Lieutenant

ABCDEFGHIJKL
MNOPQRSTUVW
abcdefg · XYZ · hijklmno
12345 · pqrstuvwxyz · 67890
Anecdote · Rothschild · Potsdam

DUMONT · LORD · BUDGET
Confession · Rousseau · Mandoline
ABCDEFGHIJKLMNOPQ
12345 · RSTUVWXYZ · 67890
abcdefghijklmnopqrstuvwxyz

PLATE 54

«KALLIGRAPHIA» · H. BERTHOLD, BERLIN & BAUER & CO. · STUTTGART

A B C D E F G H I J K

L M N O P Q R S T U

a b c · V W X Y Z · d e f

g h i j k l m n o p q r s t u v w

1 2 3 4 5 · x y z · 6 7 8 9 0

Publication · Liverpool

«INSERAT-KURSIV» · AKTIENGESELLSCHAFT FÜR SCHRIFTGIESSEREI UND MASCHINENBAU · OFFENBACH

12345 · A B C D E F G H I J K L M · 67890

abcde · N O P Q R S T U V W X Y Z · fghij

B A D E N · klmnopqrstuvwxyz · J A S O N

Interlaken · Renaissance · Euphrosyne

«GALATHEA» · ORIGINALERZEUGNIS VON J. G. SCHELTER & GIESECKE · LEIPZIG

A B C D E F G H I J K L M N O P

Q R S T U · a b c · V W X Y Z

d e f g h i j k l m n o p q r s t u v w x y z

1 2 3 4 5 · COLLEGE · 6 7 8 9 0

Adonis · Information · Orient

PLATE 55

A B C D D E E F G G H H I J
K K L M N O P Q R S S T T U
a b c d d e · V W X Y Z · f g h h i j k
k l m m n n o p q r s t u v w x y z z
1 2 3 4 5 P O T E M K I N 6 7 8 9 0
Toast · Benvenuto Cellini · Trust

A B C D E F G H I J K L M N O P Q R S
1 2 3 4 5 · T U V W X Y Z · 6 7 8 9 0
a b c d e f g h i j k l m n o p q r s t u v w x y z
Ariadne · AMSTERDAM · Bismarck

A B C D D E E F G G H H I J
K K L M N O P Q R S S T T U
a b c d d e · V W X Y Z · f g h h i j k k
l m m n n o p q r s t u v w x y z z
1 2 3 4 5 Missisippi. Artemis 6 7 8 9 0

PLATE 56

ABCDEFGHIJK
LMNOPQRSTUV
WX abcdefgh YZ
ijklmnopqrstuv
12345 wxyz 67890
MONUMENT LOUIS
Rhodes Organisation

QUILL PEN SCRIPT · E. & F. GYLES · LONDON

AABCDEFGHIJK
LMNOPQRSSTUV
12345 - WXY3 - 67890
abcdefghijklmnopqrs
Byron: tuvwxyz: Henry
Situation, Epos, Charlotte,
SAMOS, CHARKOW.

PLATE 57

ABCDEFGHI
JKLMNOPQ
RSTUVWXYZ
abcdefghijklm
nopqrstuvwxyz
1234567890

«ALTROMANISCH-KURSIV» · ORIGINALERZEUGNIS VON SCHELTER & GIESECKE · LEIPZIG

ABCDEFGHIJKL
MNOPQRSTUVW
12345·XYZ·67890
abcdefghijklm
nopqrstuvwxyz

PLATE 58

«COMMERCIAL SCRIPT» · INLAND TYPE FOUNDRY · SAINT LOUIS U. S. A.

A B C D E F G H I J K L M
N O P Q R S T U V W X Y Z

12345 - abcdefghijklmnopqrstuvwxyz - 67890
Menelaus, Reproduction, Dannecker, Stanley.

«FREEHAND SCRIPT» · STEPHENSON, BLAKE & CO. · LONDON

A B C D E F G H I J K L M N O P Q R S T U V W X Y Z
a b c d e f g h i j k l m n o p q r s t u v w x y z
1 2 3 4 5 Pamphlet, Oxford, Canada, Dickens 6 7 8 9 0
Rhum, Babel, Figaro, Episode, Route, Othello, Cognac, Zone.

«MANUSCRIPT» · BAUER & CO. · STUTTGART & H. BERTHOLD · BERLIN

A B C D E F G H I J K L M
M N O P Q R S T U V W X Y Z

a b c d e f f g h i j k l m n o p q r s t u
w x · 1 2 3 4 5 · Collection · 6 7 8 9 0 · y z
Stanley · Mandoline · Bretagne · Vignette

«FIGARO» · H.-W. CASLON & CO. · LONDON

A B C D E F G H I J K L M N O P Q R
S T U V - abcdefghijklmnopq - W X Y Z
rstu - 12345 - Testament - 67890 - vwxyz
Brahma, Confession, Aphrodite, Romulus

PLATE 59

AABBCDDEFGHIJF
KLMMNNOPPQ Qu
RRSTTUVUWXYZ
abcdefghijklmnopqrst
uvw . 1234567890 . xyz
MILLET, SPHINX, HUGO
Valparaiso, Rose, Franklin
Paris, Simon, Bagdad, Laura

«LACLEDE» · AMERICAN TYPE FOUNDERS' COMPANY · PHILADELPHIA

ABCDEFGHIJKLM
NOPQRSTUVWXYZ
abcdefghijklmnopqrsst
12345 = uvwxyz = 67890
Armand, Watteau, Elisabeth
Dumas, Kaiser, Tilly, Liszt

PLATE 60

ABCDEFGHIJKLM
NOPQRSTUVWX
12345 - YZ - 67890
abcdefghijklmnopqrst
Torino-uvwxyz-Social
GENOVA-CANTON

«HAWARDEN ITALIC» J. HADDON & Co. · LONDON.

ABCDEFGHIJK
LMNOPQRSTU
1234-VWXYZ-6789
5.abcdefghijklmnopq.0
Yacht-rstuvwxyz-Niger
KAISER - SIGNOR
ADELINA - FRED

PLATE 61

A A B C D E F G H I J K L M
N O P Q Qu R S T U V W X Y Z
a a b c d d e f g h i j k l m n o p p q r r s t t u v
1 3 2 4 5 · Nancy · x y z z · Samoa · 6 7 8 9 0
Aalesund · Calame · Turban · Muse

A B C D E F G H I J K L M M M
N O P Q Qu R S T U V W X Y Z
a b c d d e e f f g h i j k l l m n o p p q r s s ß t t u v w x y z
Helsingfors, Oratorium, Nicaragua, Cervantes, Aboukir,
Litograph, 1 2 3 4 5 6 7 8 9 0 Rossini,

A B C D E F G H I J K L M M N O P Q
1 2 3 4 5 · R S T U V W X Y Z · 6 7 8 9 0
a b c d e e f g b i j k l m n o p q r s t u v w x y z
SAMOA · MUKDEN · NODZU
Lugano, Atlas, Siam, Bonn, Tibetaner, Yalu

PLATE 62

ABCDEFGHIJKLMNOPQ
12345 · RSTUVWXYZ · 67890
abcdefghijklmnopqrstuvwxyz
ROYAL · TOKIO · GRATIS
Bayreuth · Mikado · Helsingfors

ABCDEFGHIJKLM
NOPQRSTUVWXYZ
abcdefghijklmnop
12-qrstuvwxyz-67
345 KNAUS BARON 890
Chamberlain, Salomon

ABCDEFGHIJKLM
NOPQRSTUVWXY
abcdefgh Z ijklmnop
Club · qrstuvwxyz · Paul

PLATE 63

ABCDEFGHIJKLLM
NOPQRSTUVWXYZ
abcdefghijklmno
l · pqrstuvwxyz · 6
2345 · BICYCLE · 7890
Hobbema · Islam · Ravenna

ABCDEFSHIJKLMNO
12 · PQRSTUVWXYZ · 67
345 · abcdefghijklmn · 890
opqrst · BALFOUR · uvwxyz
Stuck · Alma Tadema · Journal
Daniel · Phidias · Maria · Balzac

PLATE 64

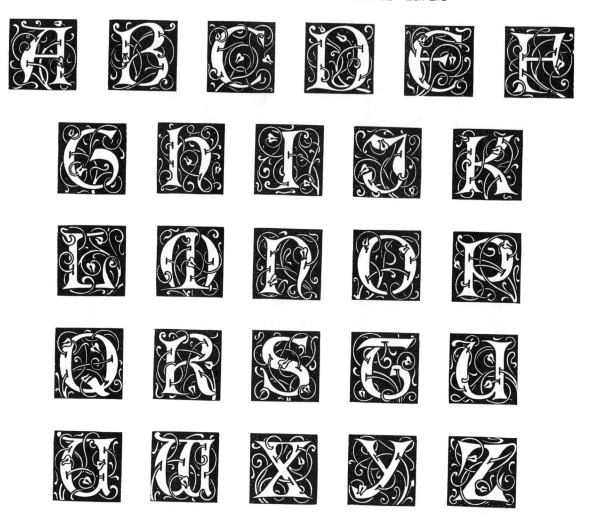

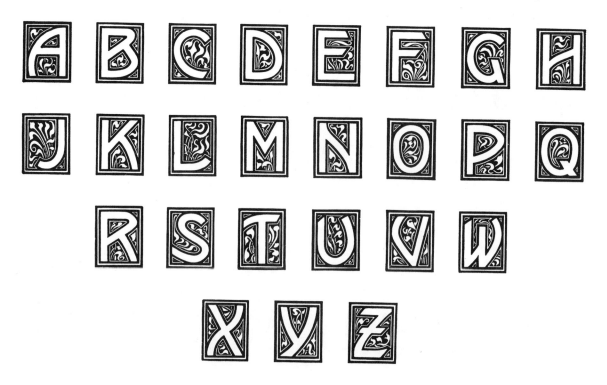

PLATE 65

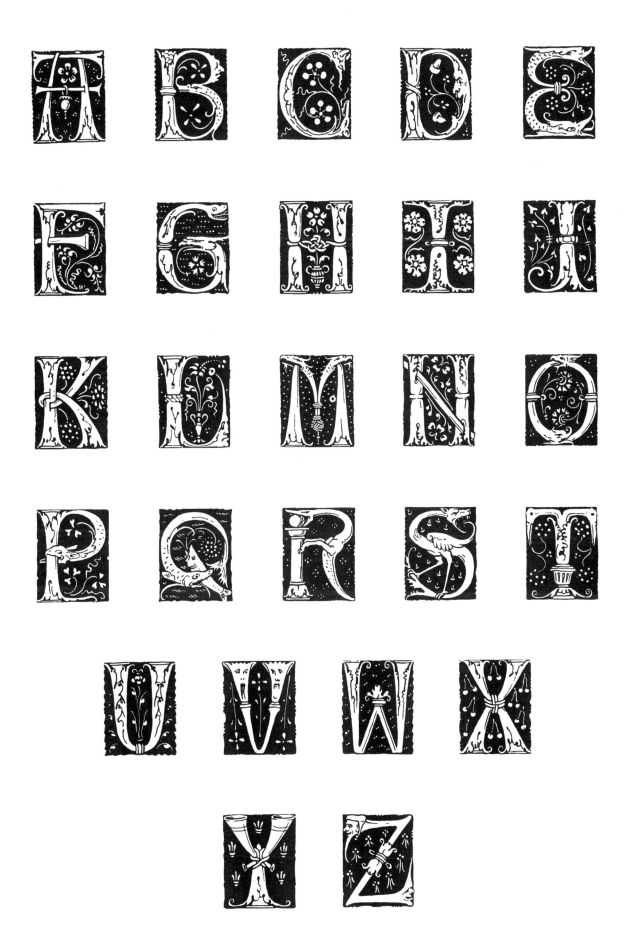

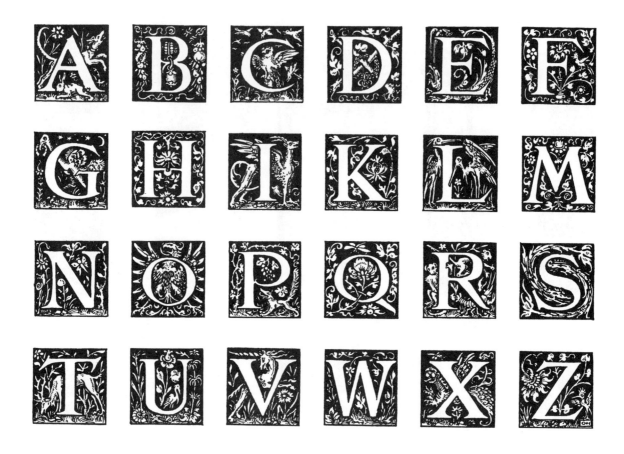

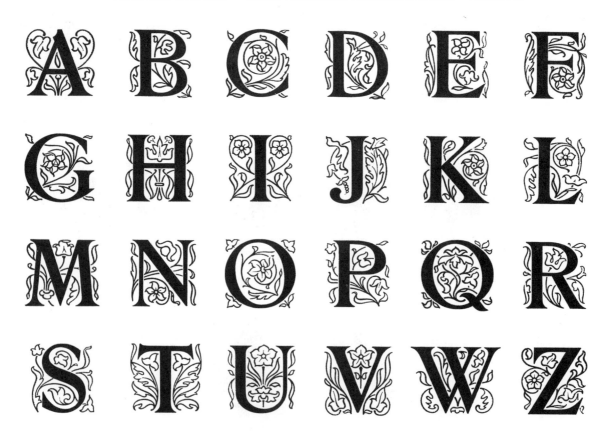

PLATE 67

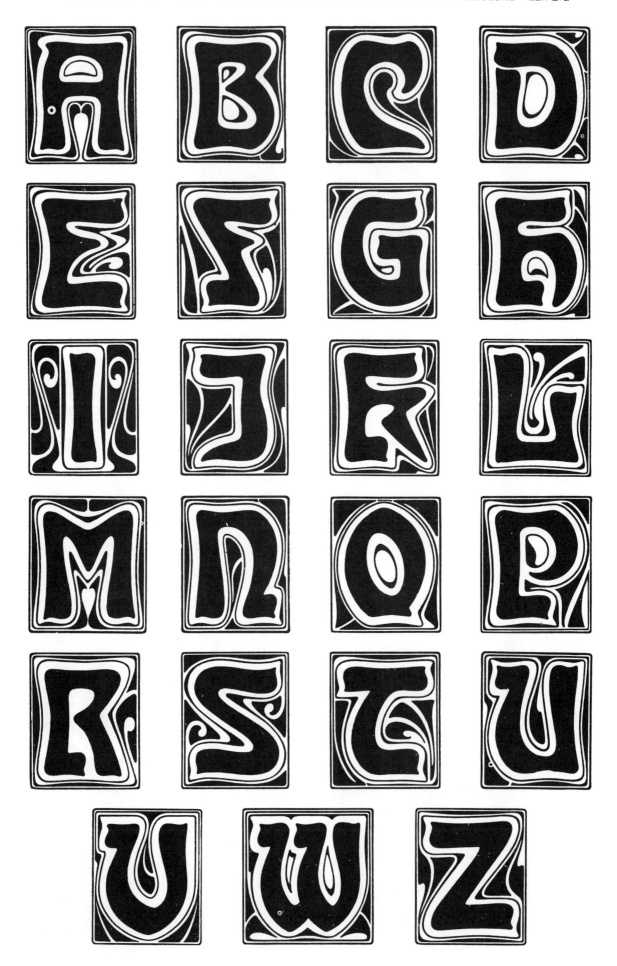

PLATE 69

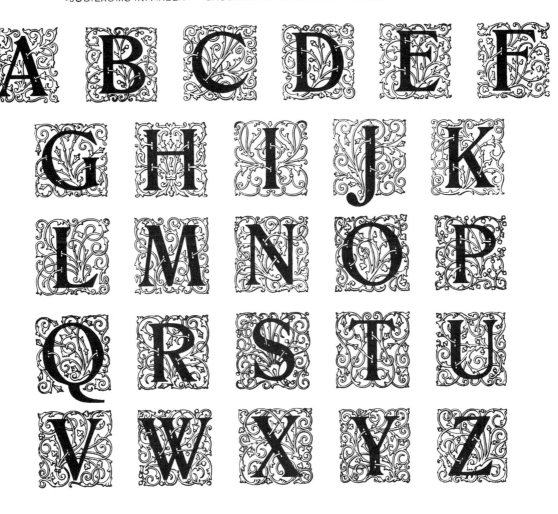

«ELZEVIER-INITIALEN» · SCHRIFTGIESSEREI FLINSCH · FRANKFURT A. M.

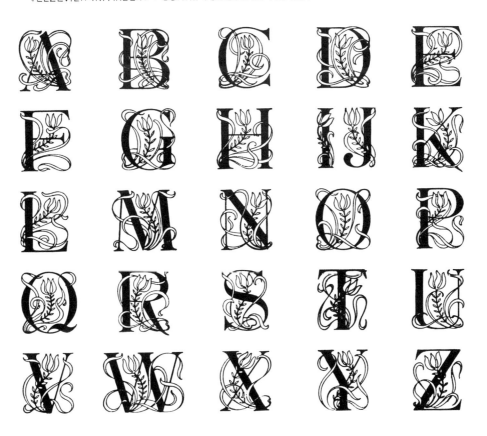

PLATE 70

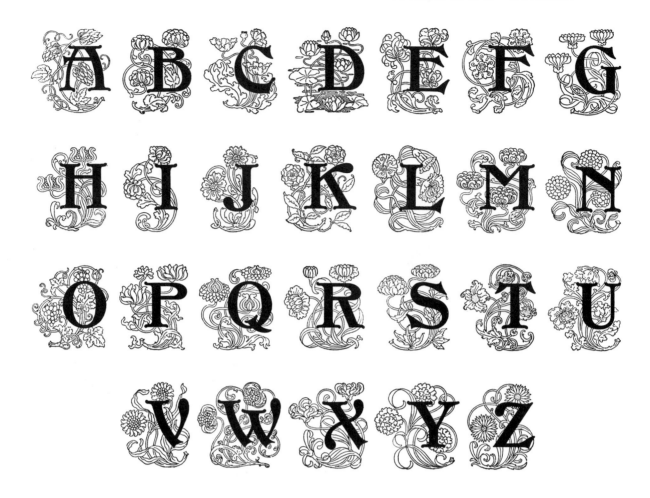

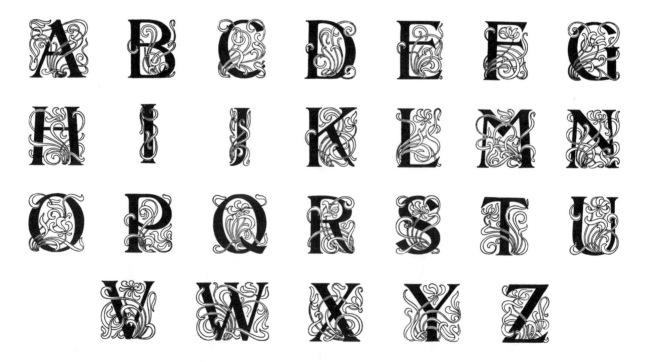

PLATE 71

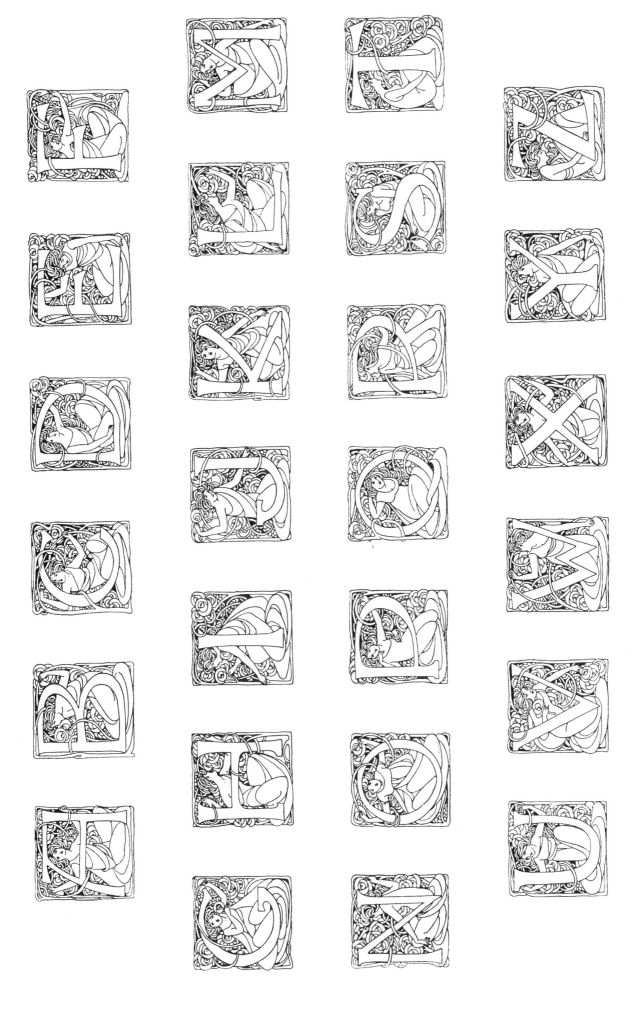

PLATE 72

INITIALEN VON ETHEL LARCOMBE

PLATE 73

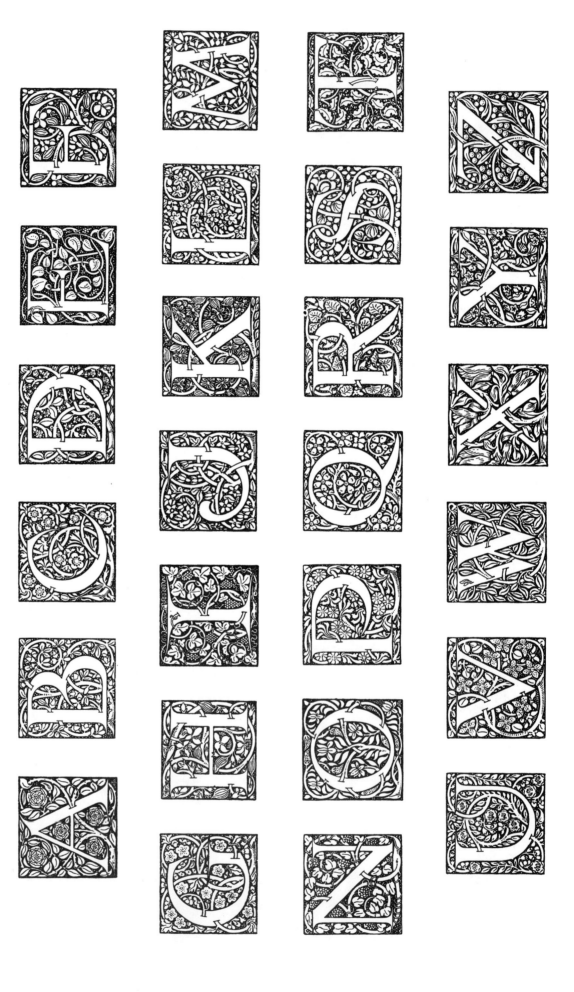

INITIALEN VON A. A. TURBAYNE.

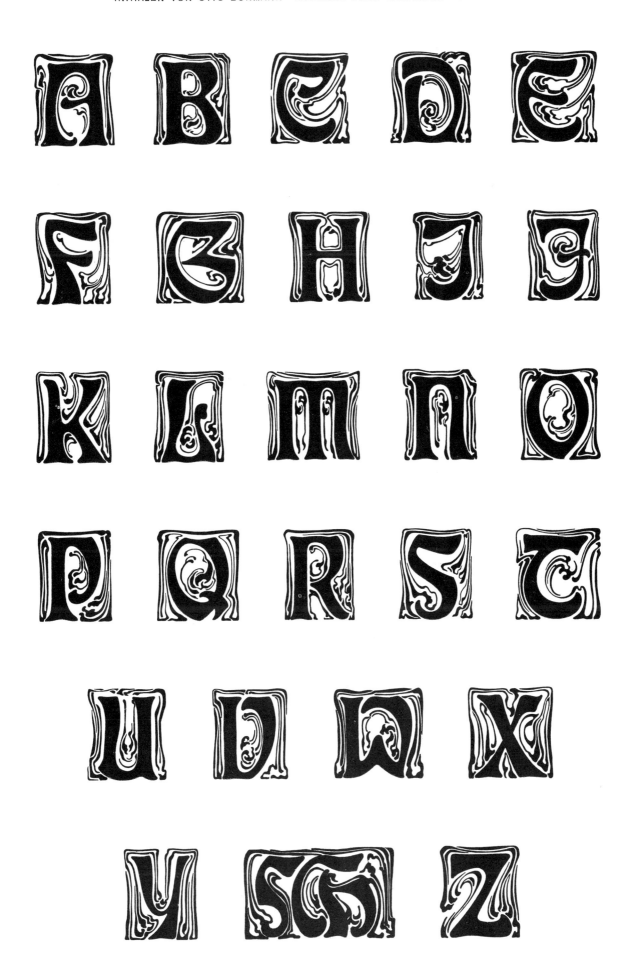

PLATE 74

PLATE 75

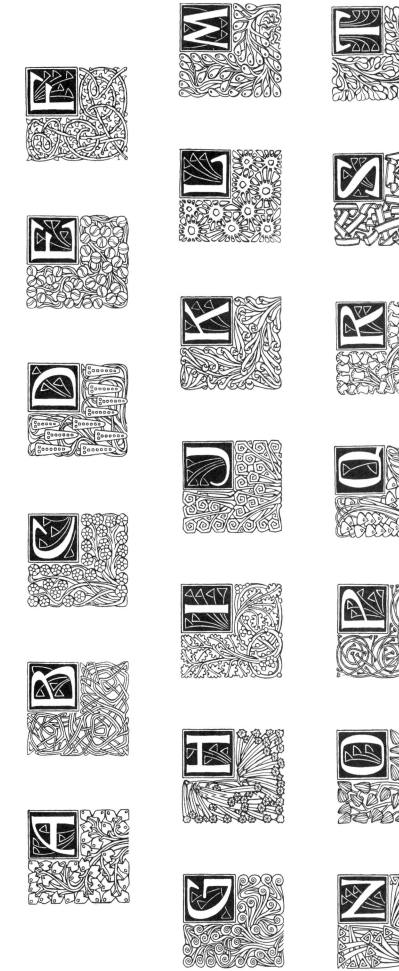

Initialen von M. J. Gradl.

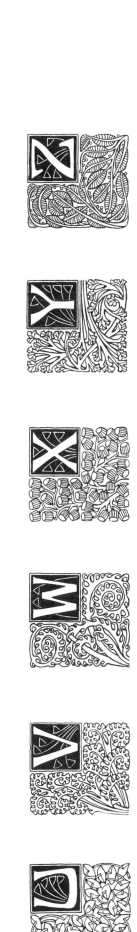

PLATE 76

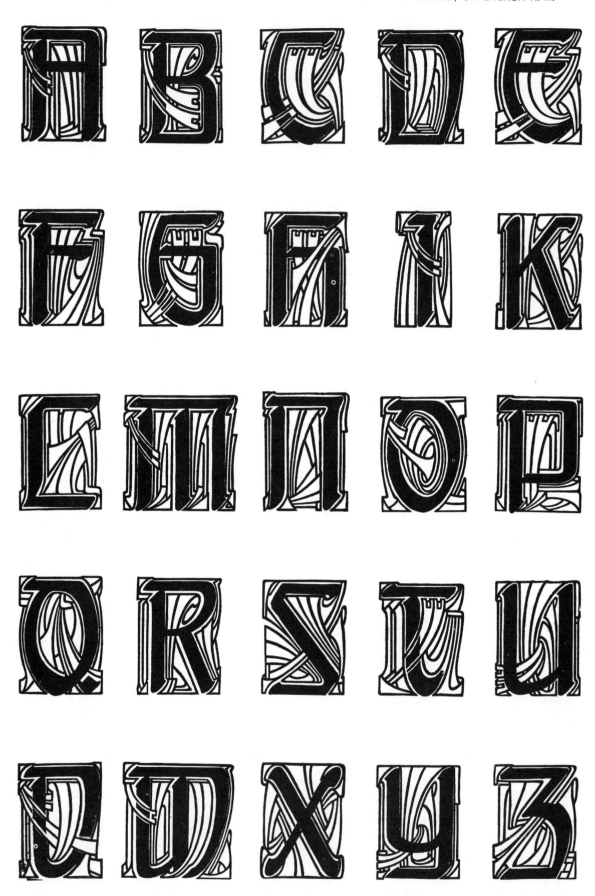

PLATE 77

PLATE 78

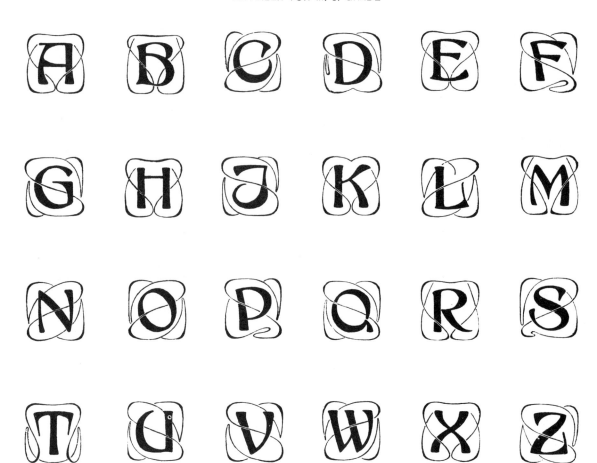

«RÖMISCHE INITIALEN» · WILHELM GRONAU'S SCHRIFTGIESSEREI · BERLIN-SCHÖNEBERG

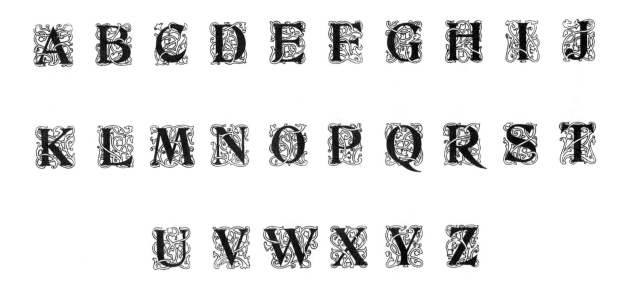

PLATE 79

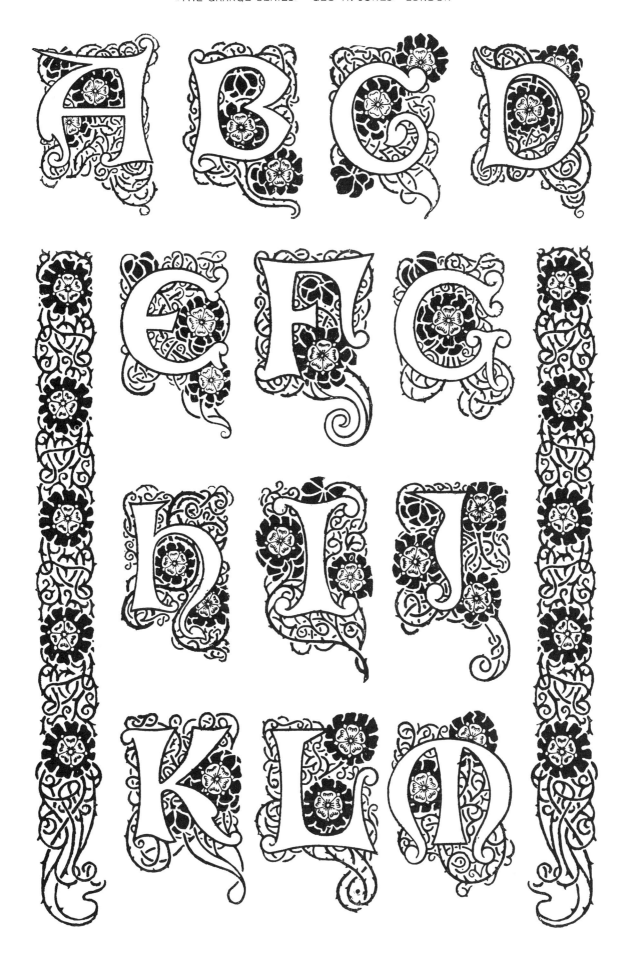

PLATE 80

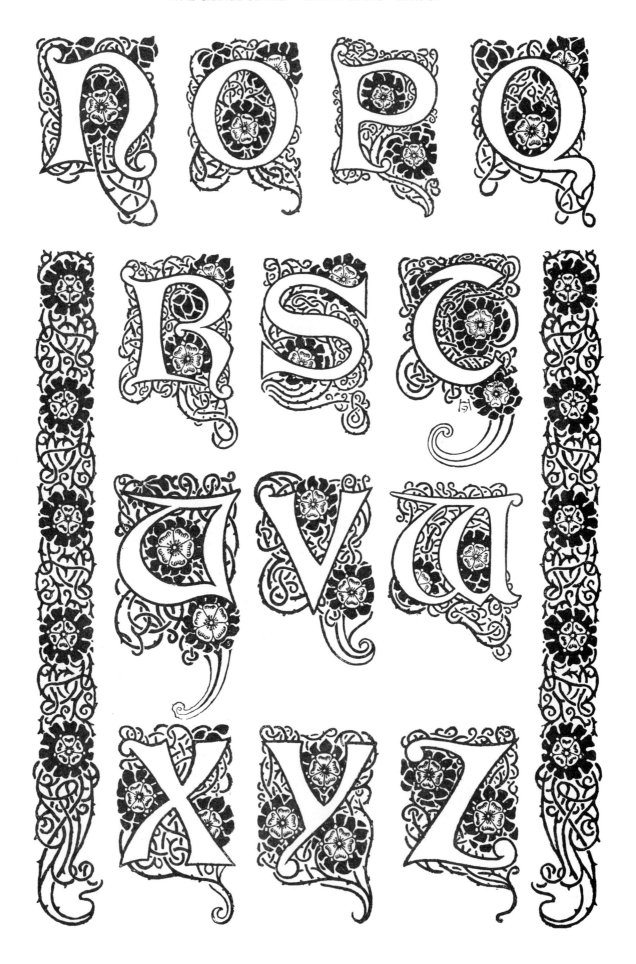

PLATE 81

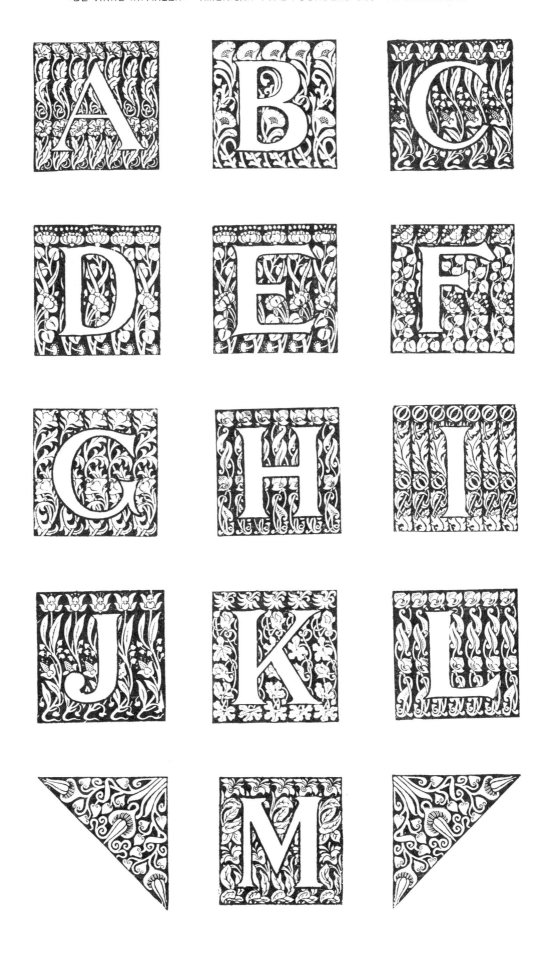

PLATE 82

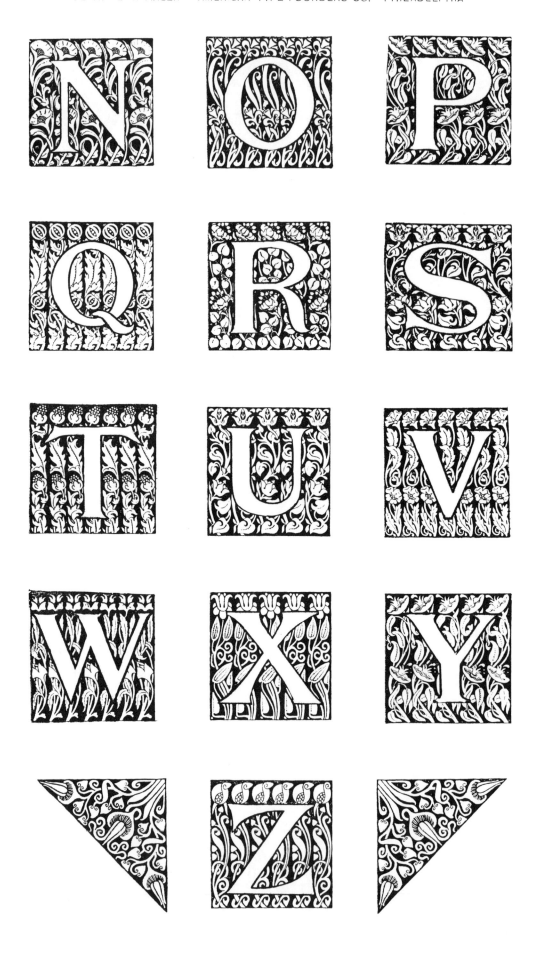

PLATE 83

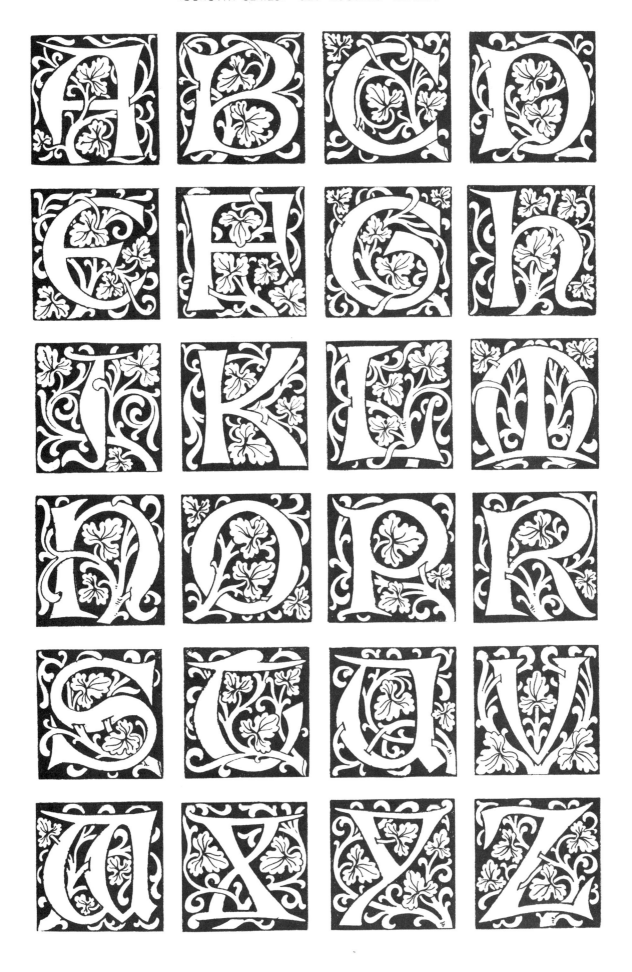

PLATE 84

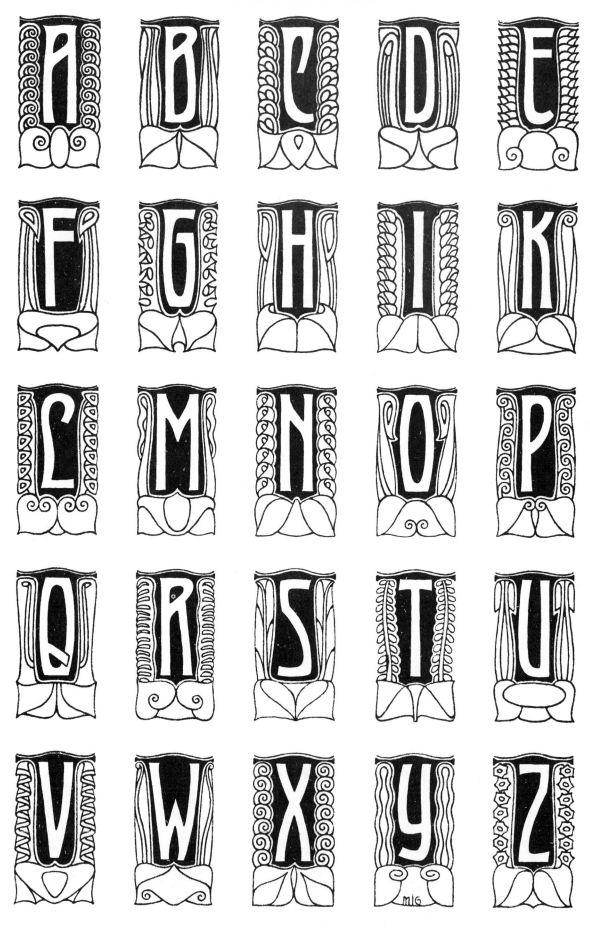

PLATE 85

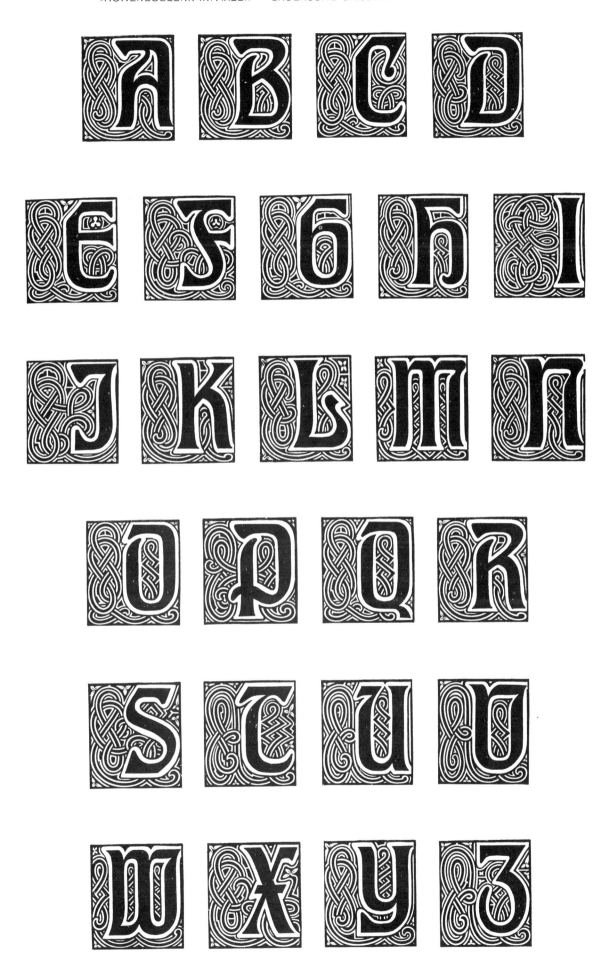

PLATE 86

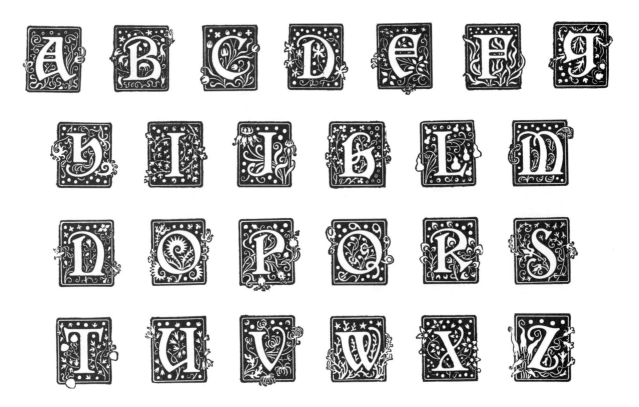

INITIALEN VON EUGÈNE BELVILLE

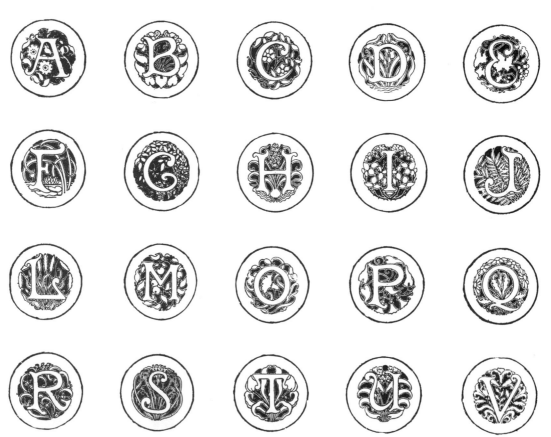

PLATE 87

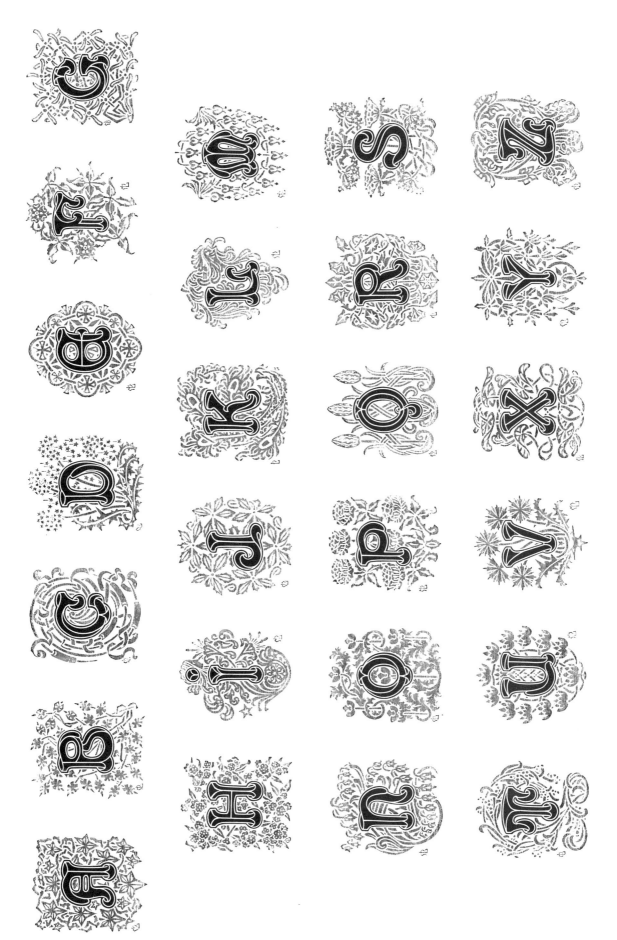

INITIALEN VON MARCEL LENOIR · SCHRIFTGIESSEREI TURLOT · PARIS

PLATE 88

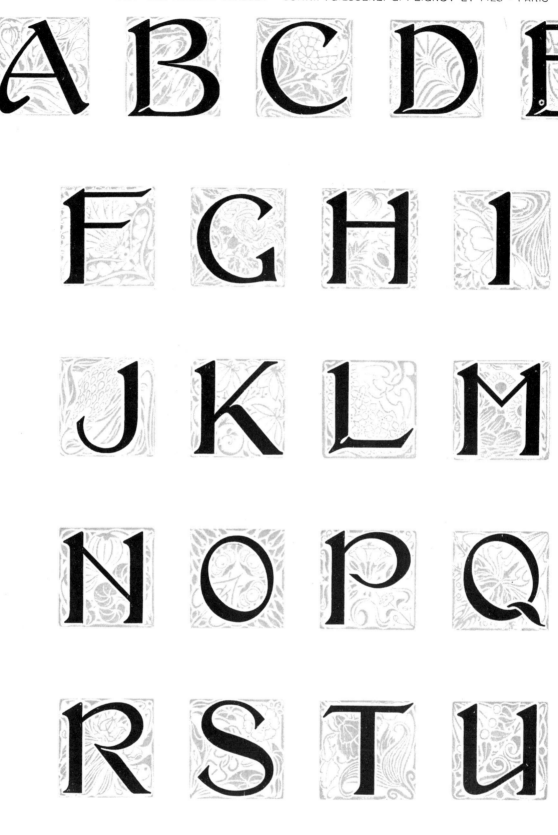

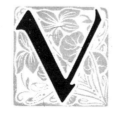 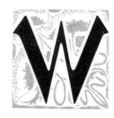 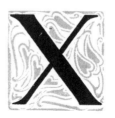

PLATE 89

PLATE 90

 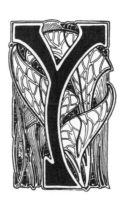 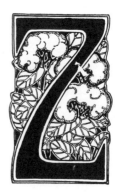

PLATE 91

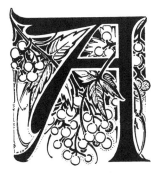
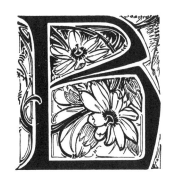

PLATE 92

PLATE 93

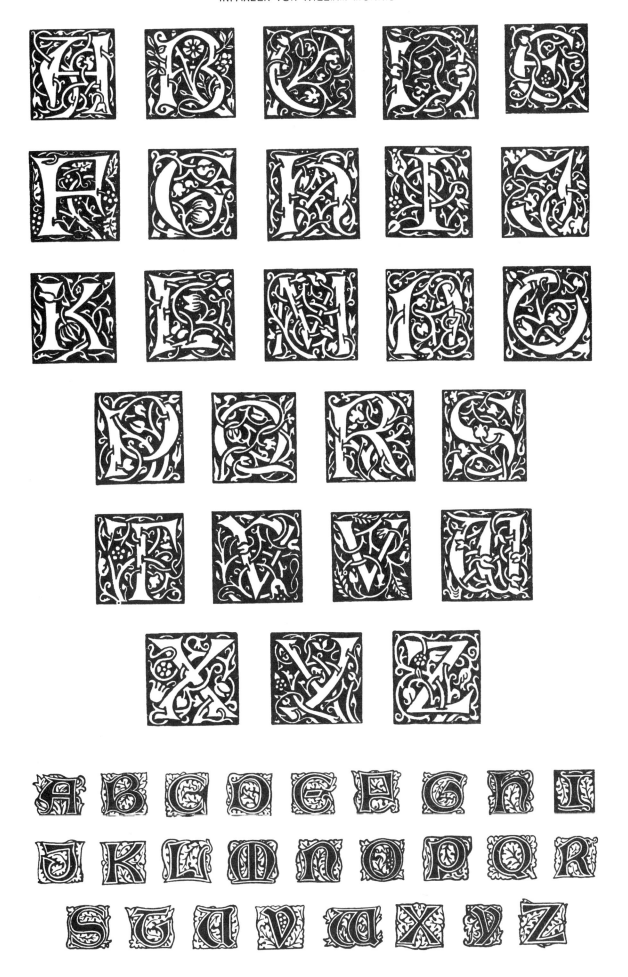

PLATE 94

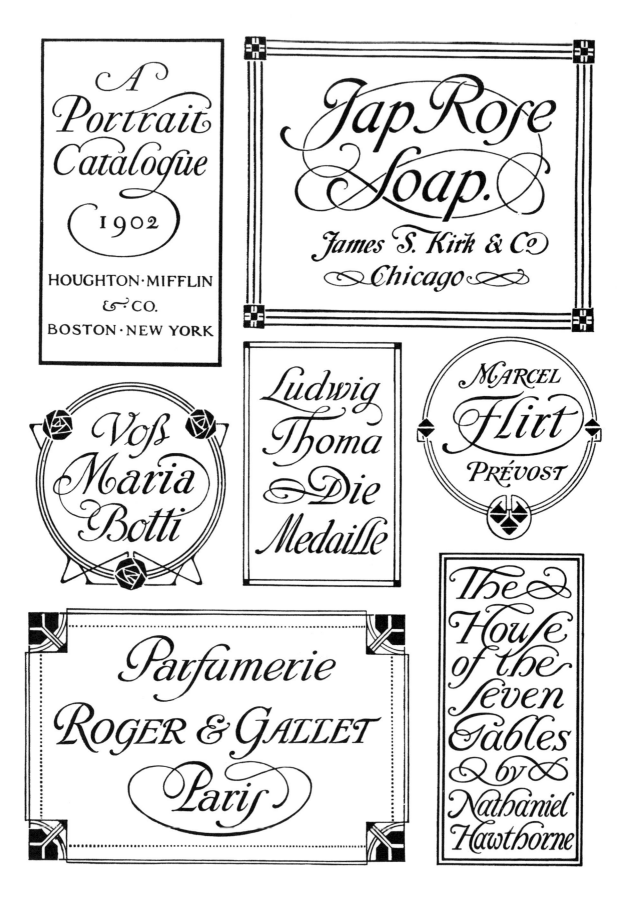

PLATE 95

ELSE WINTERSTEIN
PUTZMACHERIN
WESTERLAND=SYLT

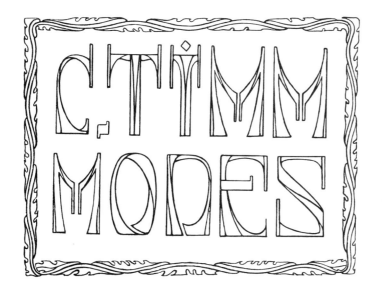

C. TIMM
MODES

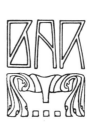

BAR

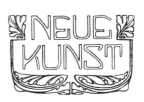

NEUE
KUNST

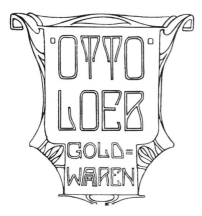

OTTO
LOEB
GOLD=
WAREN

FRIED·
LADNER
UHREN

CAFÉ
PUCK

R·MÜLLER

PLATE 96

RESTAURANT
BAHNHOF
STUTTGART

FRÜHSTÜCK
DINERS
SOUPERS
BELEGTE
BRÖDCHEN

GEMÄLDE SALON
GEÖFFNET TÄGLICH
VON 10-1.U 2-3 UHR

GEÖFFNET EINTRITT
VON 10-12 50 PFENNIG
VORMITTAG KINDER
VON 1-3 MILITÄR
NACHMITTAG 30 PFENNIG
AUSSTELLUNG
GIESSEN

MAX FRITZ
TISCHLEREI
SCHILLERSTRASSE

KAKAO
KAFFE
THEES
CHOKO:
LADEN
CONFÜ:
TÜREN

VERLAG
MODERNE
WISSENSCHAFT
TECHNISCHES
DICHTUNGEN
VORLAGE
WERKE
MONATS
HEFTE

PLATE 97

The New Gallery
· HIGH · CLASS · PICTURES ·

EXPOSITION
PERMANENTE
DE
TABLEAUX
SCULPTURES
GRAVURES
OBJETS D'ART

GRAND
RESTAURANT
LEDUC
SALONS & CABINETS

VERLAGSBUCHHANDLUNG
J. Hoffmann
· STUTTGART ·

SUMMER · SALE
OF
SURPLUS · STOCK

PIANOS
ERARD
STEINWAY
IBACH
GÜNTHER
PLEYEL
orgues

PLATE 98

TenToonsTelling
van oude
Schilderijen
der
Vlaamsche School

Dentelles
Spitze
Laces
Encajes

G·Vanzype
Mélasse
en
Gros
Produits
des
Flandres

Industrie Nationale
Solvay & Cº
Huitres & Moules parquées
Blankenberghe·Ostende·Nieuport

PLATE 99

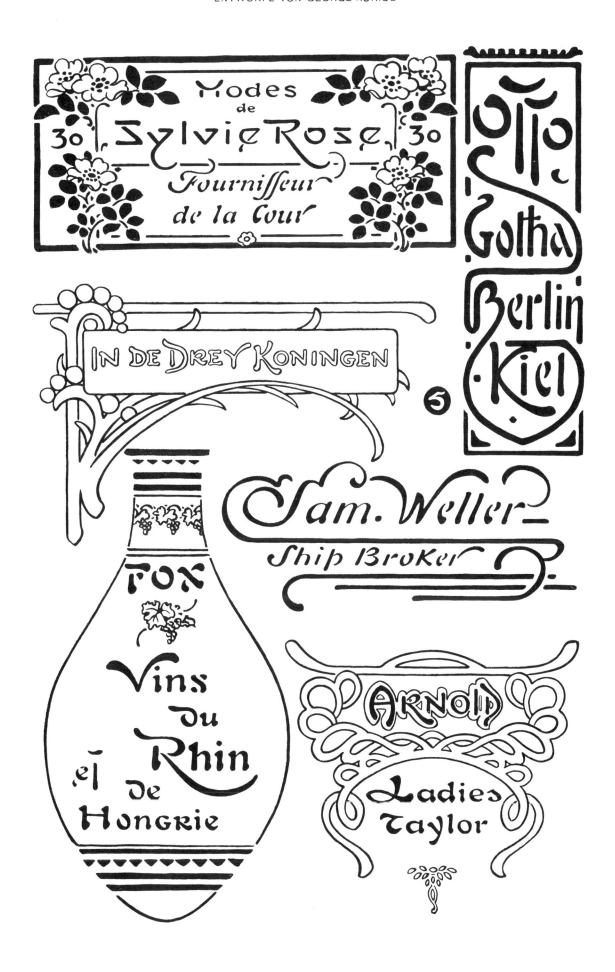

PLATE 100

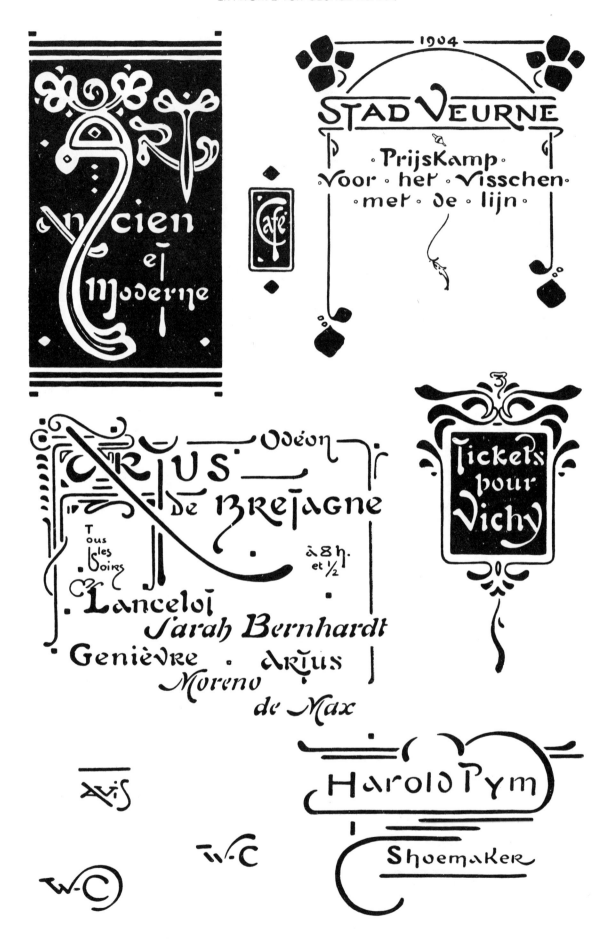

PLATE 101

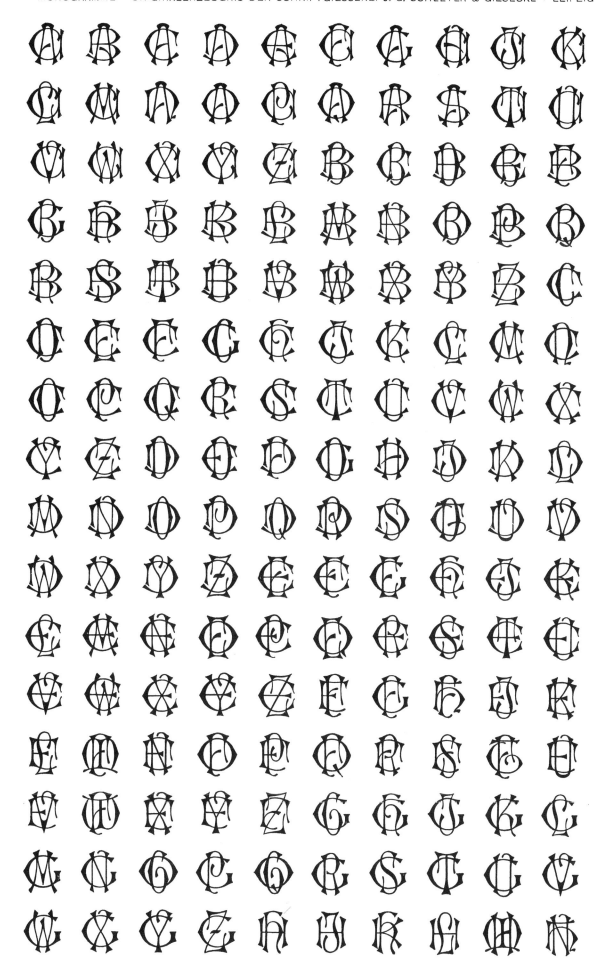

PLATE 102

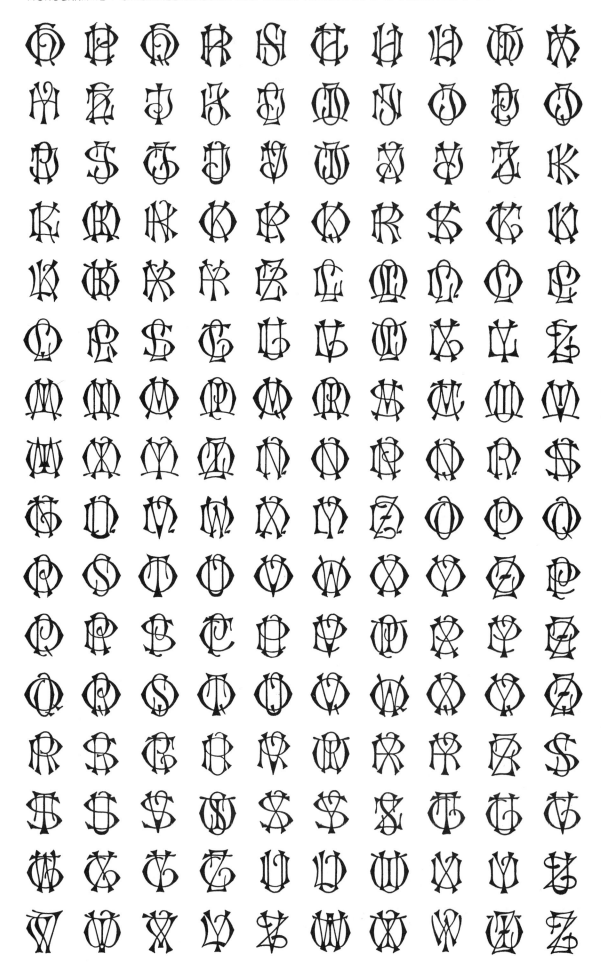

PLATE 103

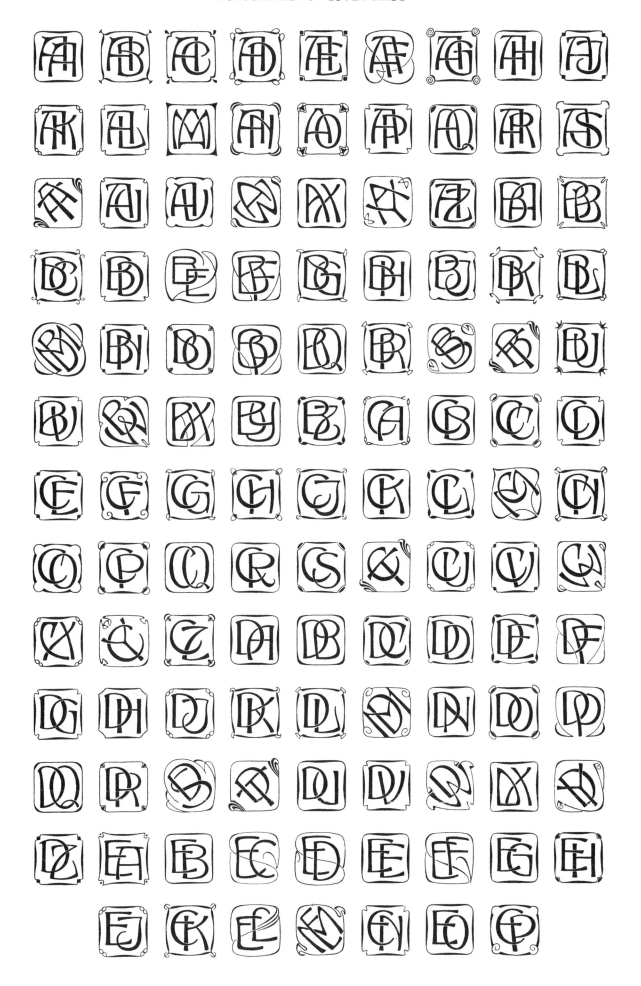

PLATE 104

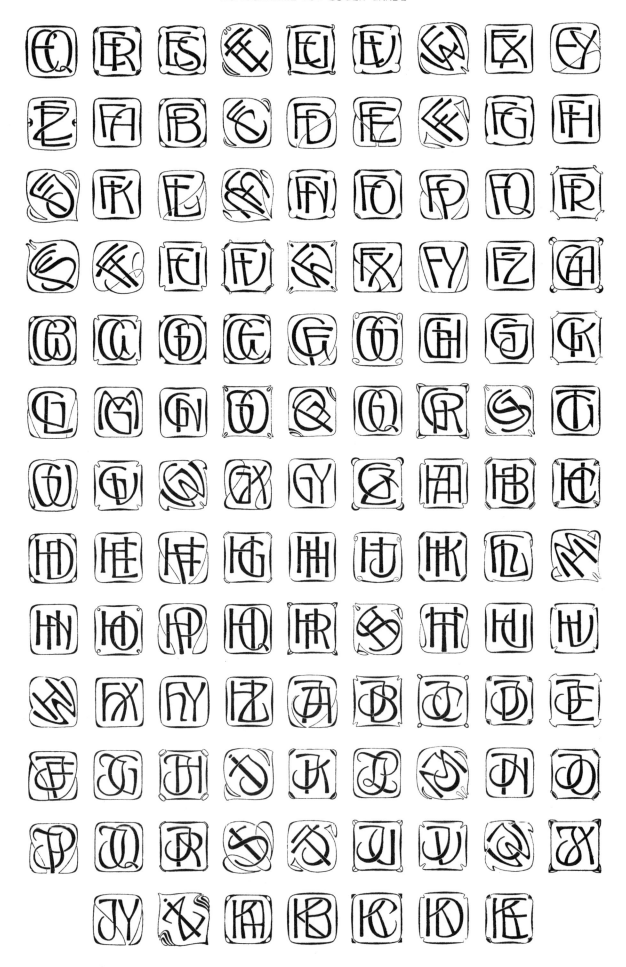

PLATE 105

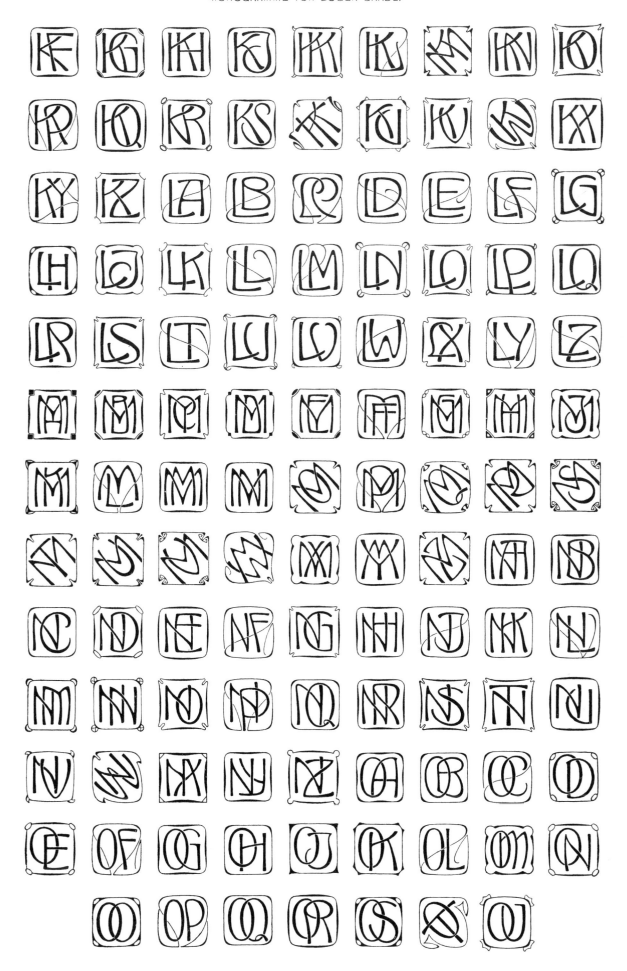

PLATE 106

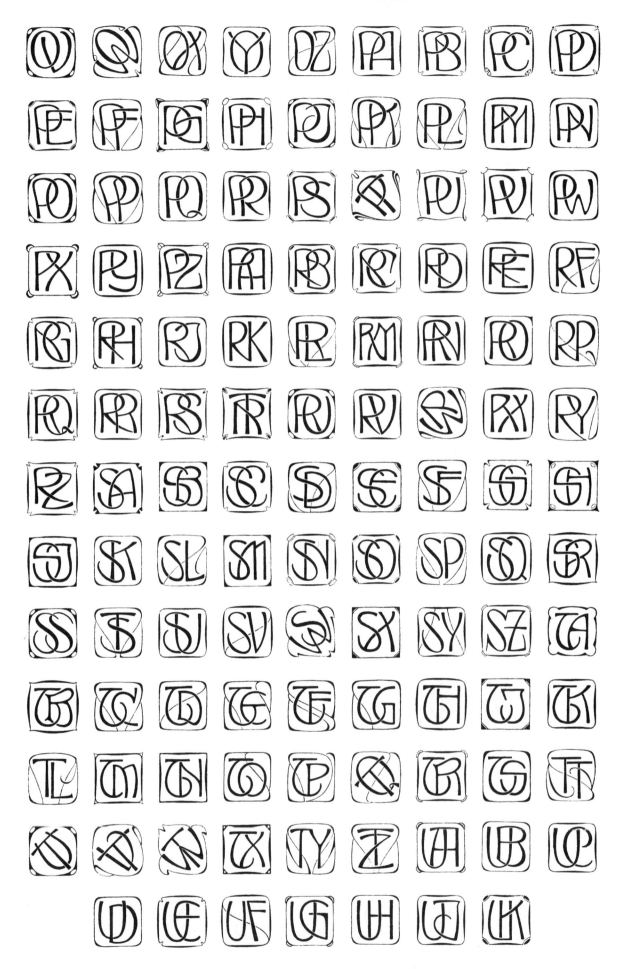

PLATE 107

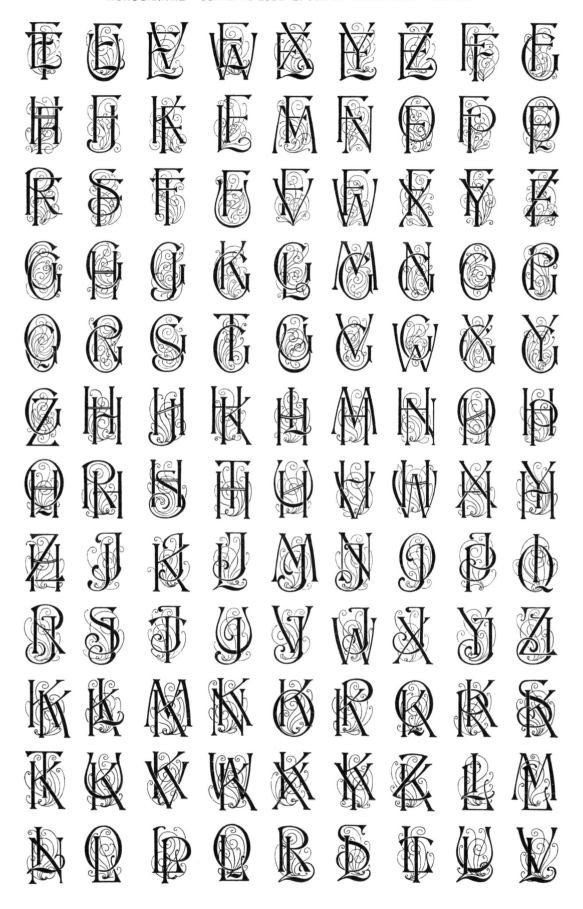

PLATE 110

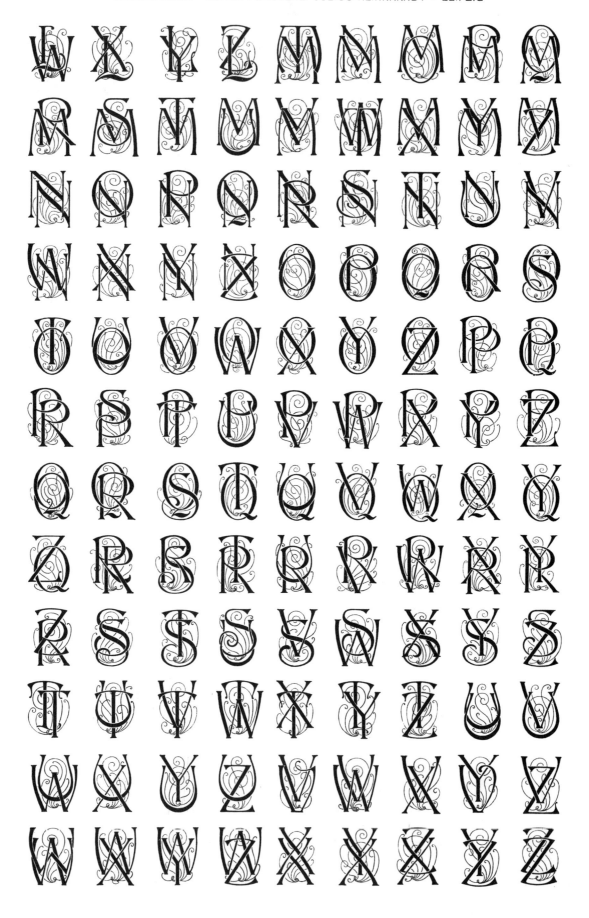

PLATE 111

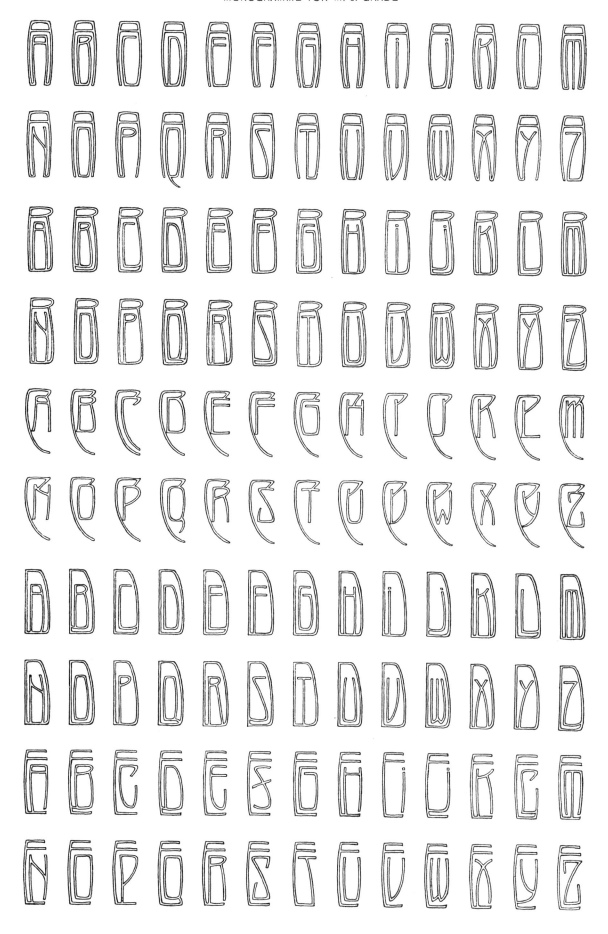

PLATE 112

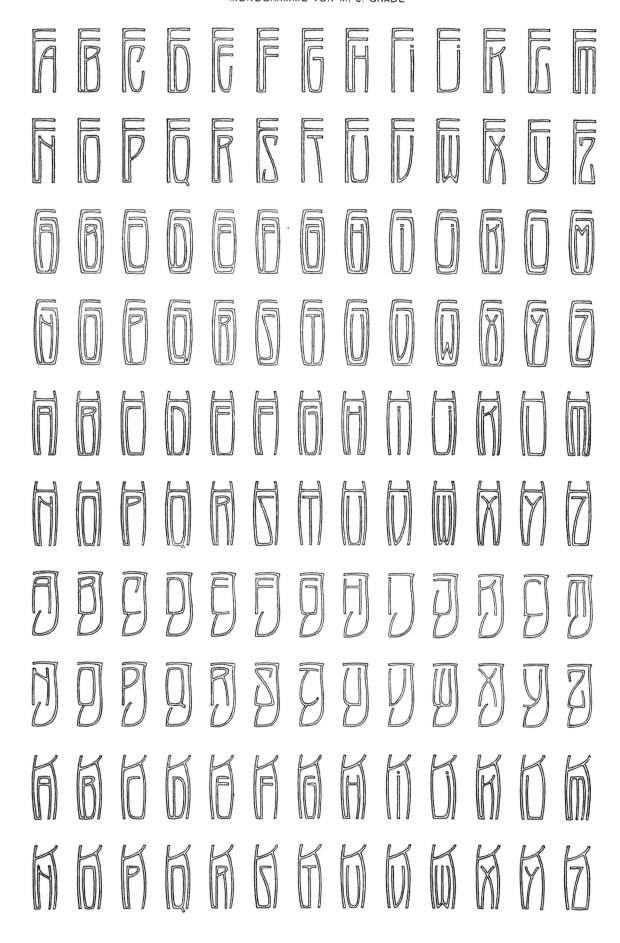

PLATE 113

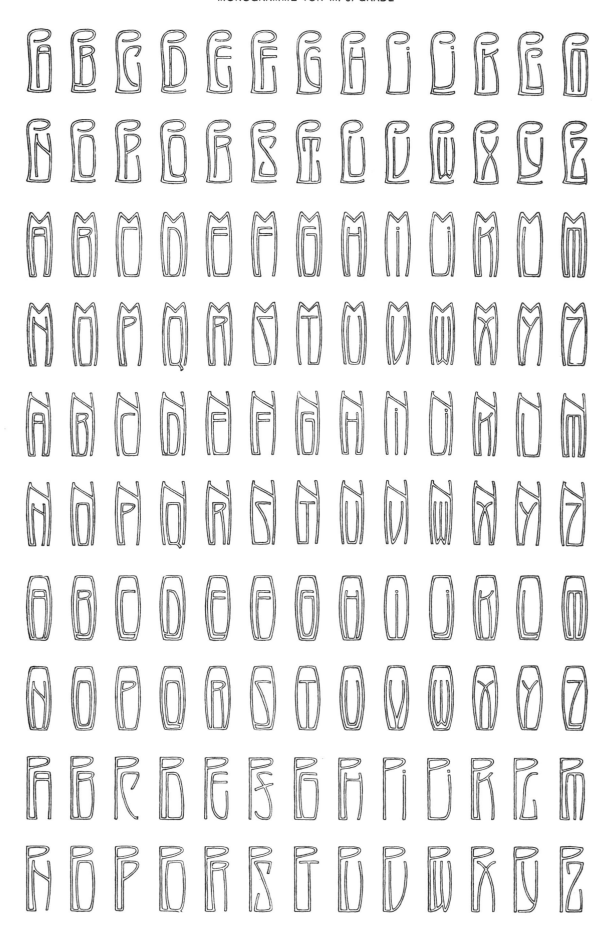

PLATE 114

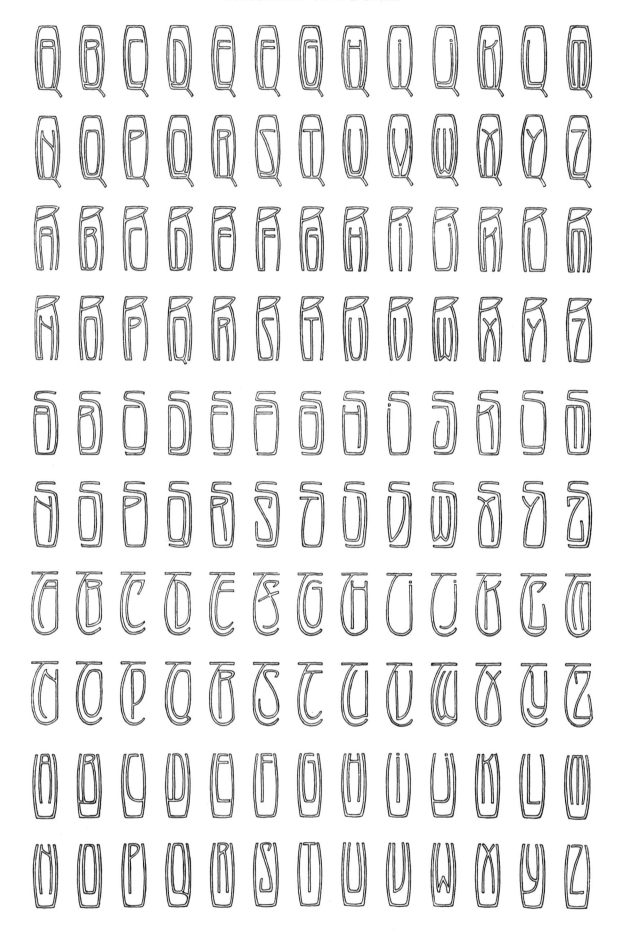

PLATE 115

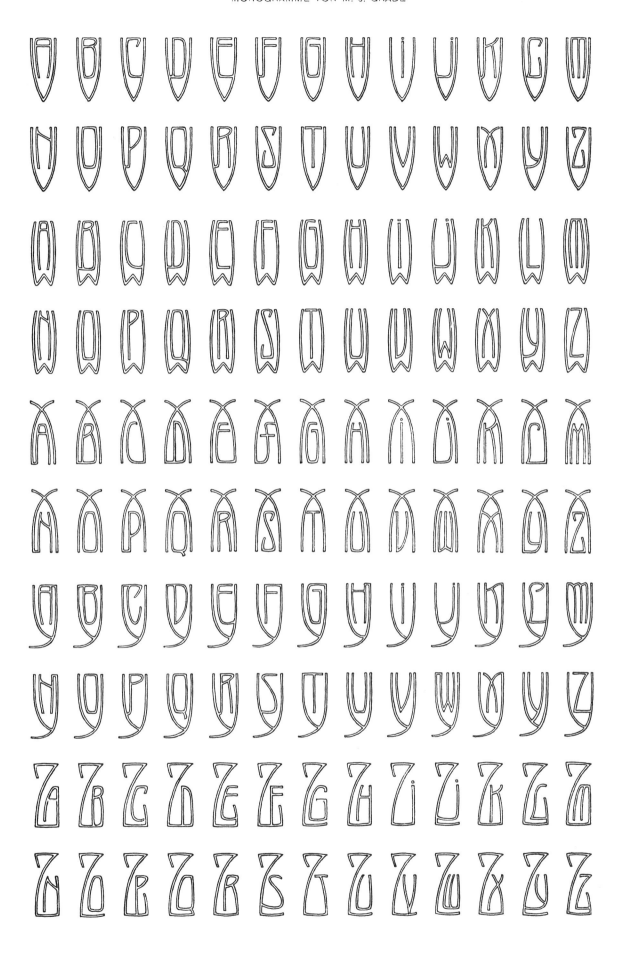

PLATE 116

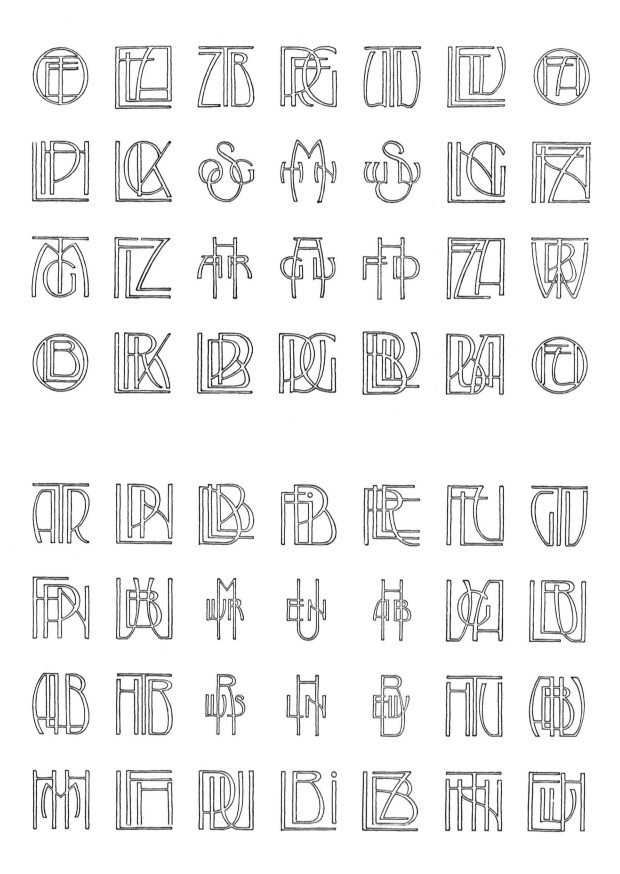

PLATE 117

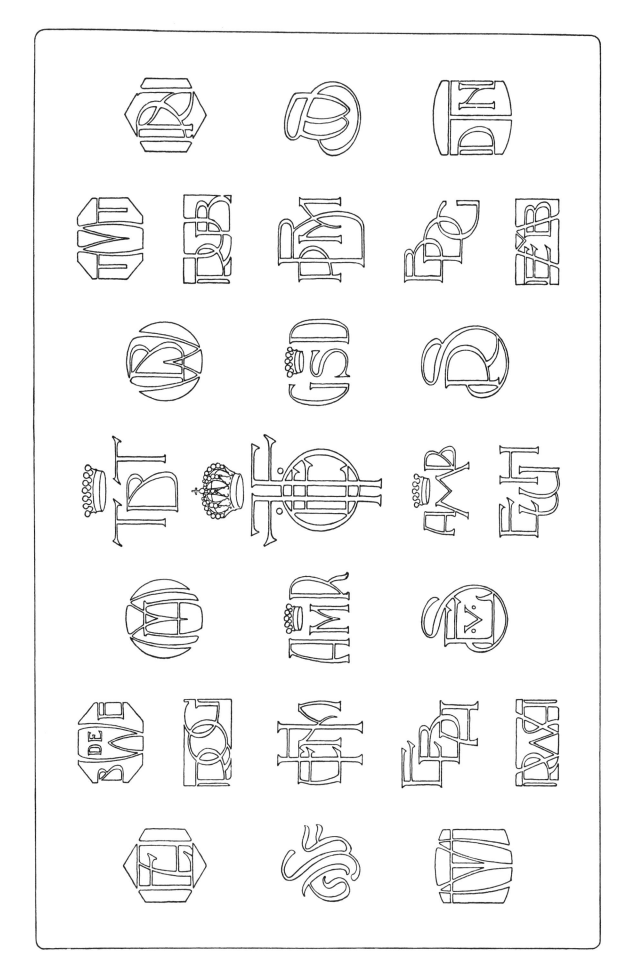

PLATE 118

DREIBUCHSTABEN-MONOGRAMME VON H. NOWACK

PLATE 119

GEZEICHNETE VORNAMEN VON H. NOWACK

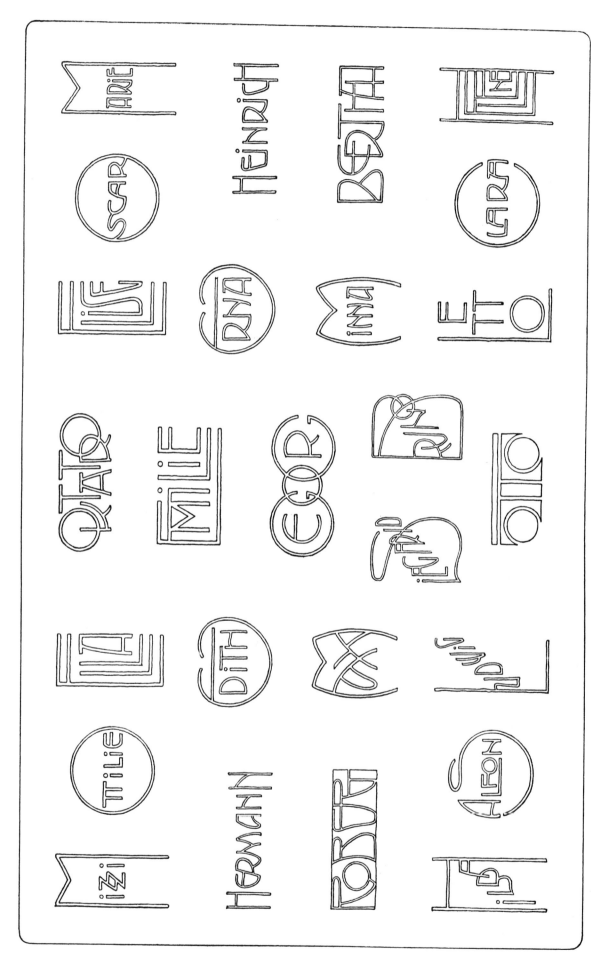

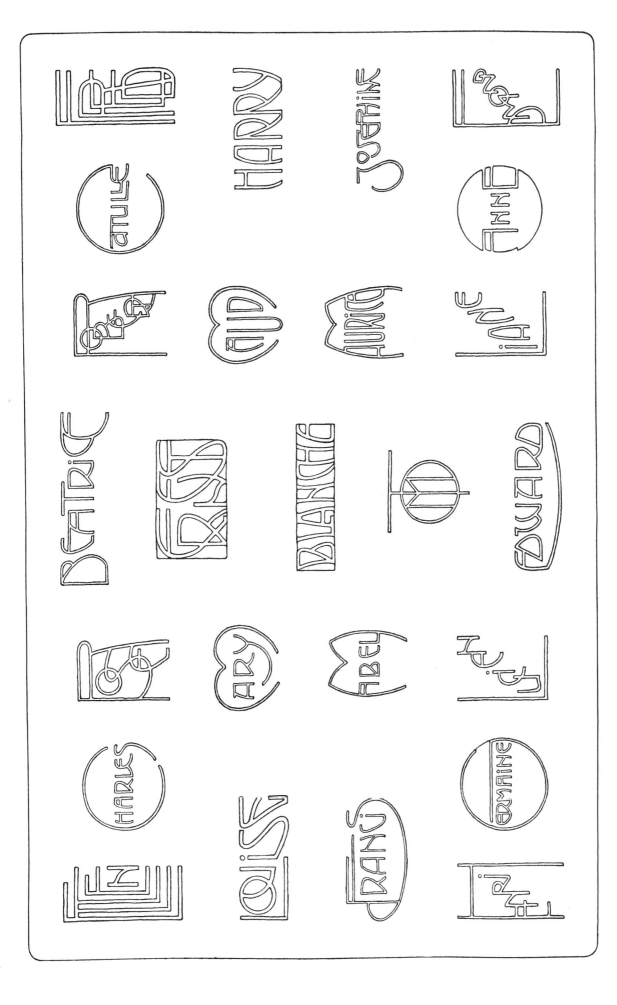

GEZEICHNETE VORNAMEN VON H. NOWACK

PLATE 120

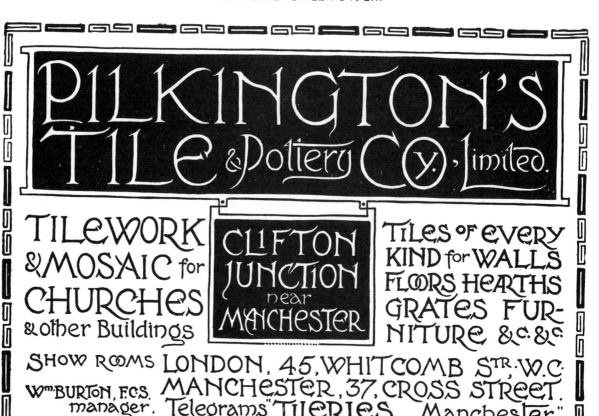

PLATE 121

PLATE 122

CIGARREN & CIGARETTEN
·C·RENARD·

REIHE 8

CASSA

RANG 1

LOGE 4

MEUNIER FISCHER BLACK & COMPAGNIE

W. SHMIDT SOHN
RASEUR
FRISEUR
COIFFEUR
MANICURE

PASSAGE BUREAU ID. MAIER

CAFÉ & AMERICAN BAR:

CAFÉ RESTAURANT INTERNATIONAL

IMPORT EXPORT V. MARTIN EN GROS EN DETAIL

ENTWORFEN VON M. J. GRADL

PLATE 123

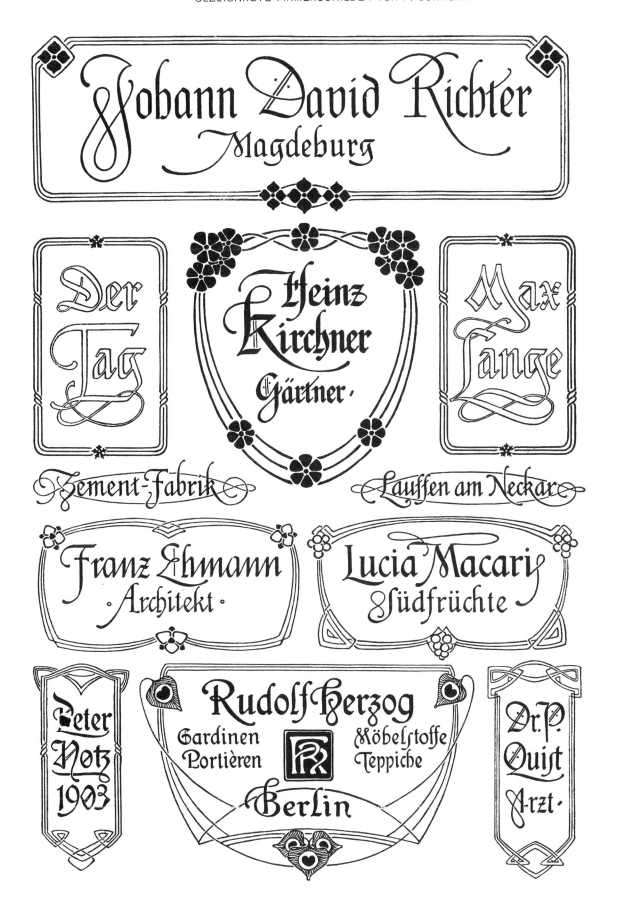

PLATE 124

GEORG SCHÖTTLE MÖBEL-FABRIK STUTTGART SOLIDESTE AUSFÜHRUNG SÄMTLICHER MÖBEL

AUFGANG ZUR GALLERIE

CERMODS AM FUSSE DER ZUGSPITZE HOTEL & PENSION DREI MOHREN VORZÜGLICHE KÜCHE MÜNCHNER BIERE TIROLER WEINE FISCHWASSER M. JÄGER MÄSSIGE PREISE

DECKEN UND WÄNDE FÜR DAS MODERNE HAUS VON M. J. GRADL 24 FOLIOTAFELN IN FARBDRUCK PREIS -M. 26.-

COMPTOIR VON PAUL MAUR

DER MODERNE STIL

SCHIEDMAYER PIANOFORTEFABRIK HARMONIUMS / PIANOS TADELLOSE AUSFÜHRUNG STUTTGART

KUNSTWART: HERAUSGEBER: FERD. AVENARIUS VERLAG GEORG D. W. CALLWEY MÜNCHEN

MODERNE BAUFORMEN MONATSHEFTE FÜR ARCHITEKTUR PREIS DES GANZEN JAHRGANGS 12 HEFTE M. 24.- IN MAPPE M. 26.- JULIUS HOFFMANN VERLAG, STUTTGART

PLATE 125

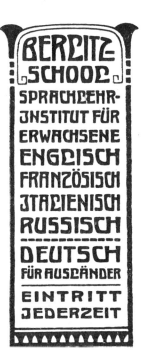

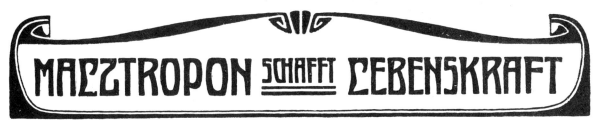

PLATE 126

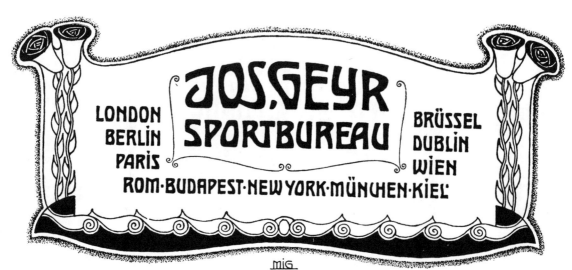

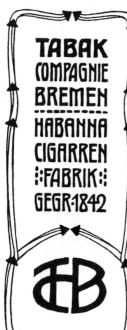

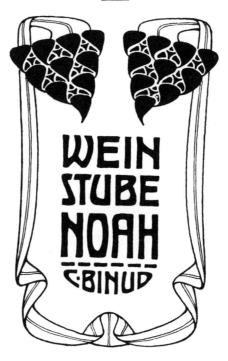

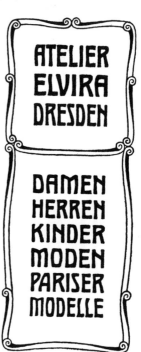

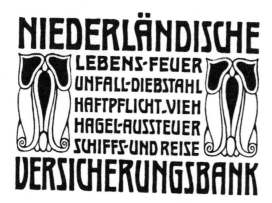

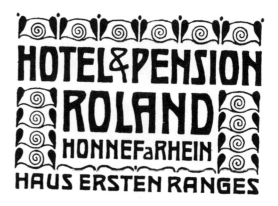

PLATE 127

Ott·Heinrich·Bürgerschule
Mairimwald i Steiermark

American
Bar · Café
USA

JAMES SHMITH

DURESCO
THE KING
of water
paints

THE SILIKATE PAINT COMP.
CHARLTON : LONDON · S·E·

HOEHL

SEC
extra
DRY

MIG

Münchener
Neueste
Nachrichten

2 AUSGABEN
TÄGLICH

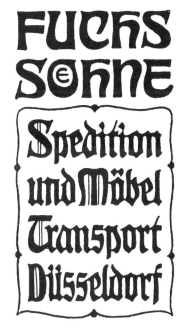

FUCHS
SÖHNE

Spedition
und Möbel
Transport
Düsseldorf

Ivers & Pond Piano Compagnie

PIANOS

12 UNTER DEN LINDEN
BERLIN & BOSTON U·S·A·

ORGELN

PLATE 128

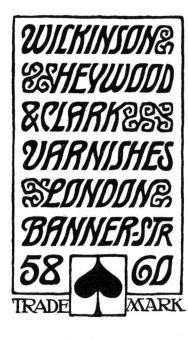

WILKINSON &
& SHEYWOOD
& CLARK &
VARNISHES
& LONDON &
BANNER-STR
58 ♠ 60
TRADE MARK

'ENRICO.
'IBOSSOS.
'FABRICA.
'MERCI DI.
METALLO.
'NAPOLI.
1501
MiG

ESTABLISHED 1862
B. WILLIAMS
TOY-BAZAR
NEW-YORK.

TOYS
DOLLS
GAMES
& NOVELTIES

NUR
EIN
PREIS

GOLDENE
ISAAK KOHN
3 MK-BAZAR
MARKTPLATZ
9

NUR
EIN
PREIS

THEE
SALON
MIKADO
. DIE .
GANZE
NACHT
OFFEN

MAISON
DUVALI
OBJETS
D'ART
MEUBLES
&
BIJOUX
POSTAMT
4

B. GANZ
& CO.
MAINZ
" "
MANUFAK-
TUR " " FÜR
VORHÄNGE
TEPPICHE
& MÖBEL-
STOFFE

PLATE 129

PLATE 130

PLATE 131

E·BRACH
MUSIKINSTRUMENTE
ERFURT

G·BÖHM
DROGUERIE
MAINZ

F.KAISER
GOLDSCHMIED
BARMEN

V.STAHL
GÄRTNER

L·BUB
MALUTENSILIEN
BERLIN

ATELIER
STEINER

R·KURZ
GLASMALER
DRESDEN

DR·LÖB
MAGDEBURG

E·BURKHARD
PIANOFABRIK
FRANKFURT%

P.STOTZ
BELEUCHTUNGS·
KÖRPER

PLATE 132

PLATE 133

PLATE 134

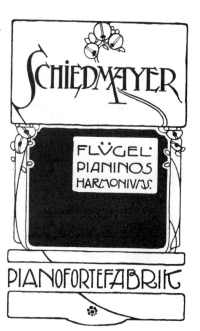

PLATE 135

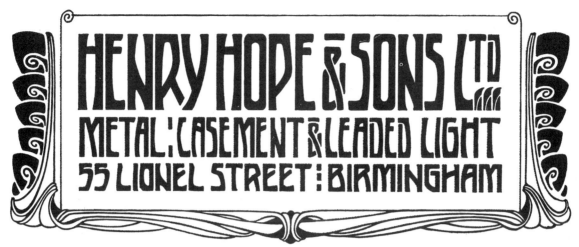

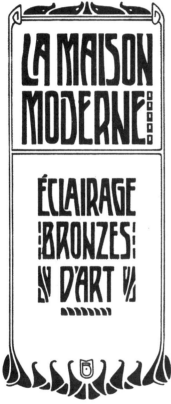

PLATE 136

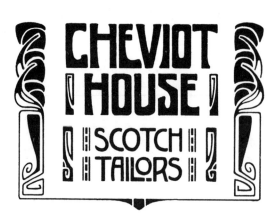

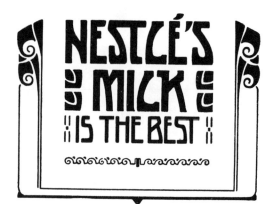

PLATE 137

DEÜTSCHE-BÜCHEREI

EINE SAMMLUNG
VON ROMANEN
NOVELLEN
& ERZÄHL-
UNGEN

MINK

DR. KELLER SCHE KURANSTALT
BAD NEROTHAL

HOTEL-HOLLÄNDISCHER HOF

SILBERDORF'S
CONSERVATORIUM
FÜR MUSIK

PAUL
WINTER

PHOTOGRAPH
BONN

PLATE 138

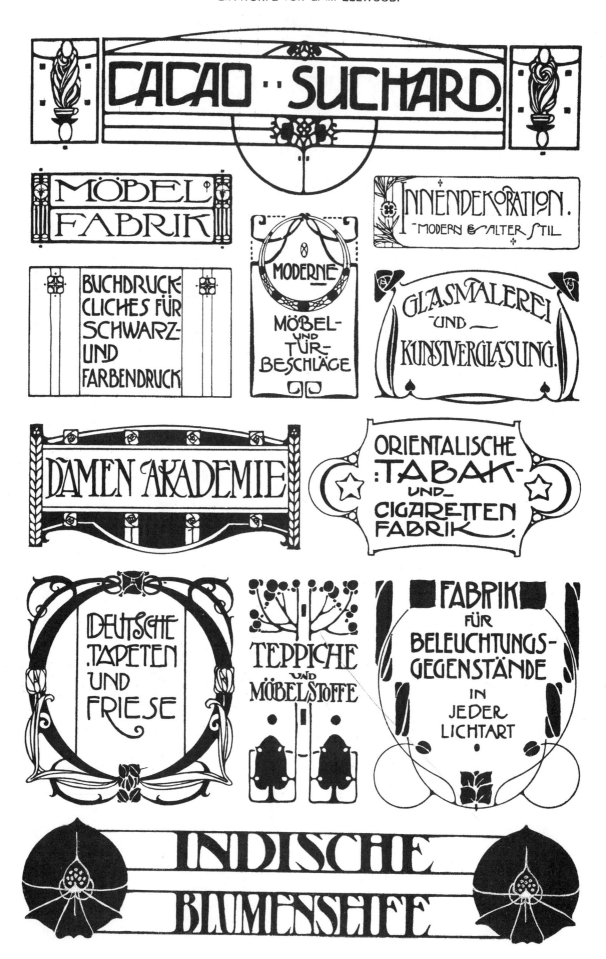

CACAO ·· SUCHARD.

MÖBEL FABRIK

INNENDEKORATION.
MODERN & ALTER STIL

BUCHDRUCK-CLICHES FÜR SCHWARZ- UND FARBENDRUCK

MODERNE MÖBEL- UND TÜR-BESCHLÄGE

GLASMALEREI UND KUNSTVERGLASUNG.

DAMEN AKADEMIE

ORIENTALISCHE :TABAK- UND CIGARETTEN FABRIK.

DEUTSCHE TAPETEN UND FRIESE

TEPPICHE UND MÖBELSTOFFE

FABRIK FÜR BELEUCHTUNGS-GEGENSTÄNDE IN JEDER LICHTART

INDISCHE BLUMENSEIFE

PLATE 139

HOWARD'S ENGLISH MADE PARQUETRY. GEORGE WRAGGE LONDON

Die Hochzeit von Ludwig Thoma

DEKORATIVE KUNST

THE HUNDRED BEST PICTURES

Daniel Low and Co GOLD·AND·SILVER–SMITHS 207 ESSEX·ST·SALEM·MASS

WALHALL DIE GÖTTERWELT DER GERMANEN

Münchener KALENDER

KUNSTWART

MÜNCHENER KALENDER

ESSEX·AND·COMPANY's WESTMINSTER·WALL· PAPERS·114·116·VICTORIA· STREET·WESTMINSTER· AND·AT·ESSEX·MILLS BATTERSEA·LOND

Reclam's Universum

L'ART NOUVEAU

ARCHITECTURAL REVIEW

BURLEY 120 Wabash Av.

Confessions of a Wife BY SPECIAL APPOINTMENT

WARING'S DECORATION·FURNITURE·UPHOLSTERY

PLATE 140

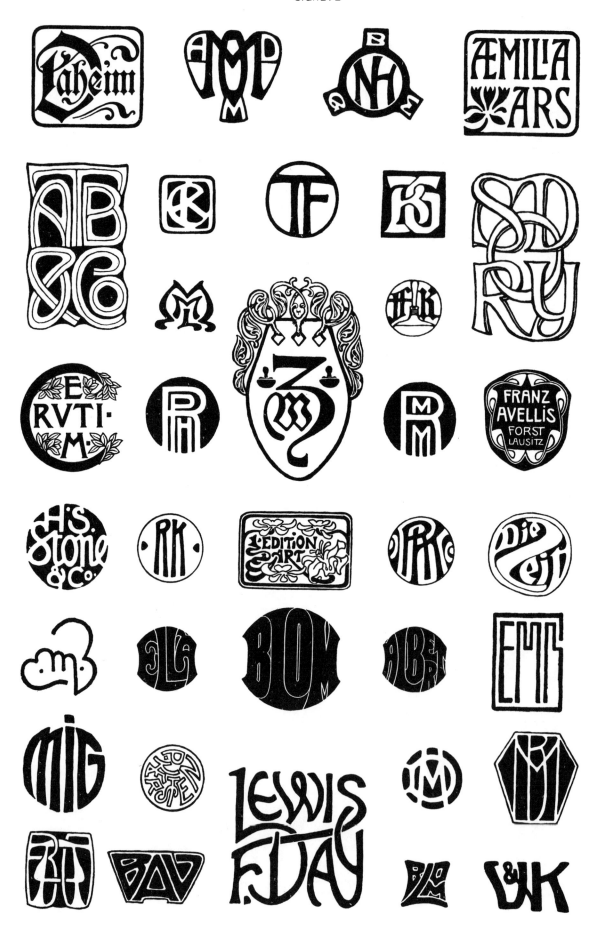

PLATE 141